Ambiguous Illusions
Images by Humberto Machado

Dedication
For my Daughters, Nephews, and Nieces

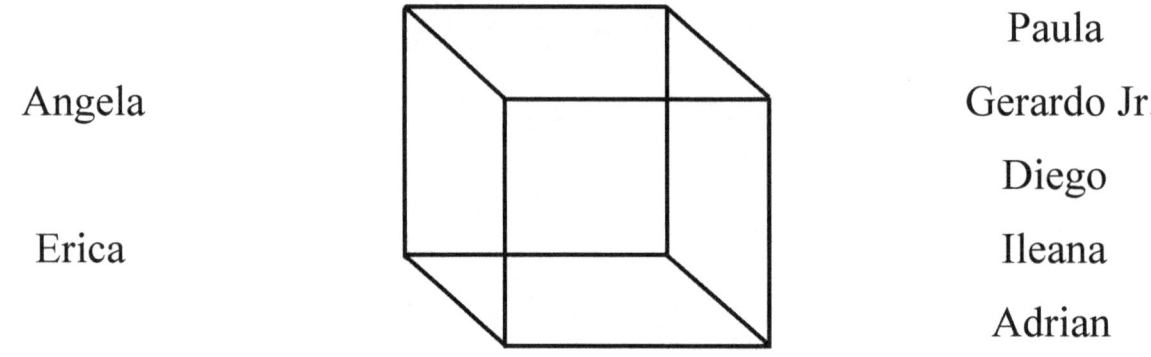

Angela

Erica

Paula

Gerardo Jr.

Diego

Ileana

Adrian

Note from the artist: The face image in the Holy Cup ambiguous illusion and the perceptual illusion of a young girl riding her bicycle are both the artist's daughters.

Ambiguous Illusions
Copyright © 2015 by Humberto Machado. All rights reserved.

This book is sold subject to the condition that it shall not, by way of trade or otherwise, be lent, resold hired out or otherwise circulated without the publisher's consent in any form of cover or binding other than that in which it is published and without a similar condition, including this condition, being imposed upon the subsequent purchaser.

© Front and back cover design by Humberto Machado
© Images and text by Humberto Machado
www.ambiguousillusions.com

Published in the United States of America
ISBN 978-1-329-57764-0
1. Art / Design / Drawing / Images / General

Acknowledgements

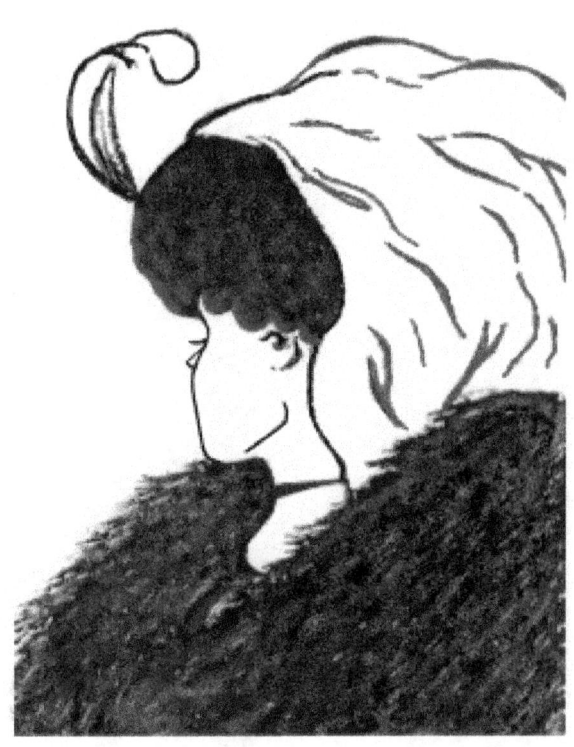

I would like to express my greatest gratitude to the people who have supported me throughout my book. I am grateful to my art teacher, Mr. Steve Klein, who introduced to me an ambiguous illusion (shown above) of a young woman-old lady also known as "*My Wife and My Mother-in-Law*" by British Cartoonist Ely William Hill (1887-1962). It was this ambiguous illusion which inspired me to create some of my own. At last but not the least, I want to thank my family and friends who appreciated my artwork and motivated me. Finally, to God, who made things possible?

Introduction

Have you ever been tricked by an ambiguous illusion? Ambiguous illusions are images or pictures that can be deceptive or misleading to our brains. Try out some of these illusions and discover just how challenging it can be for your brain to accurately interpret each image.

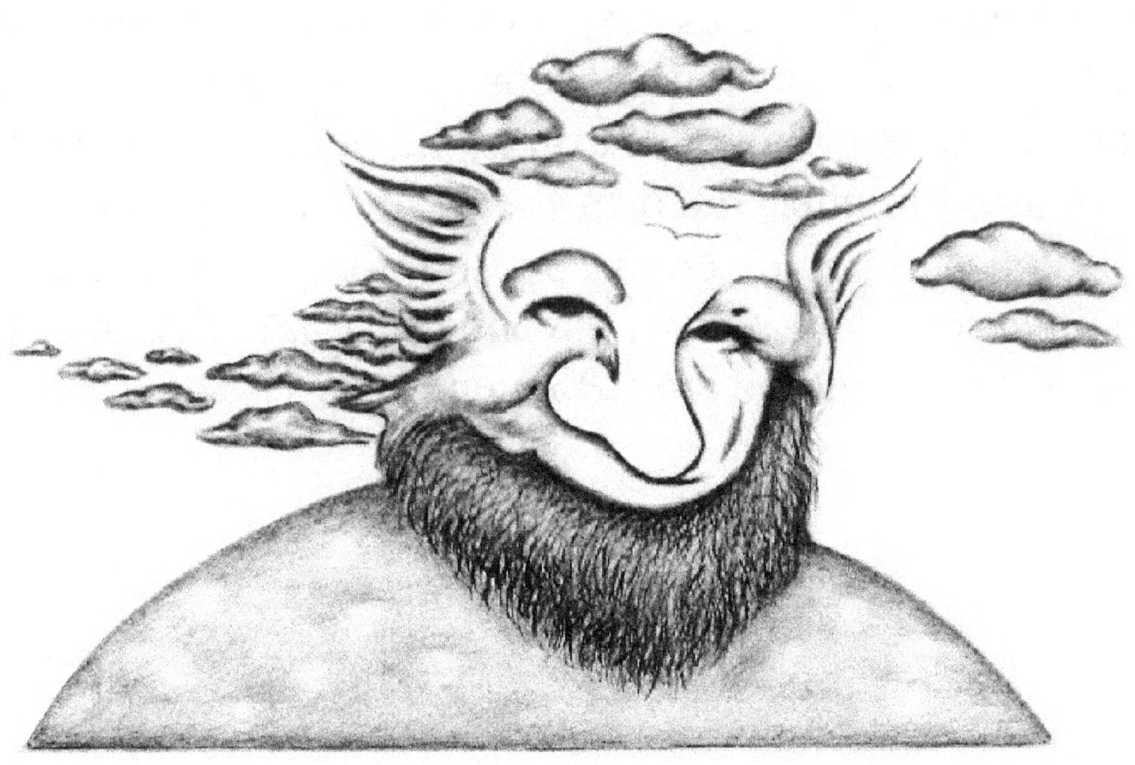

About the book

Ambiguous Illusions – are simple images meant to fool the perception with unfamiliar form which sometimes tend to play games with the mechanics of our eyes.

In this book you will observe some very creative ambiguous figurative illusions by Humberto Machado where both aspects share space, and cannot exist without the other. Ambiguous illusions are fascinating because they remind us of the discrepancy between perception and reality. These illusions occur as a result of how information is received through the eye and how that information is interpreted in the brain. At the end of this book you will come across some famous optical illusions by some very well-known psychologist and physicist like Ewald Hering and Johann Poggendorff.

Negative Space – in art, is the space around and between the subjects(s) of an image. Negative space may be the most evident when the space around a subject, and not the subject itself, forms an interesting or artistically relevant shape, and such space is occasionally used to artistic effect as the "real" subject of an image.

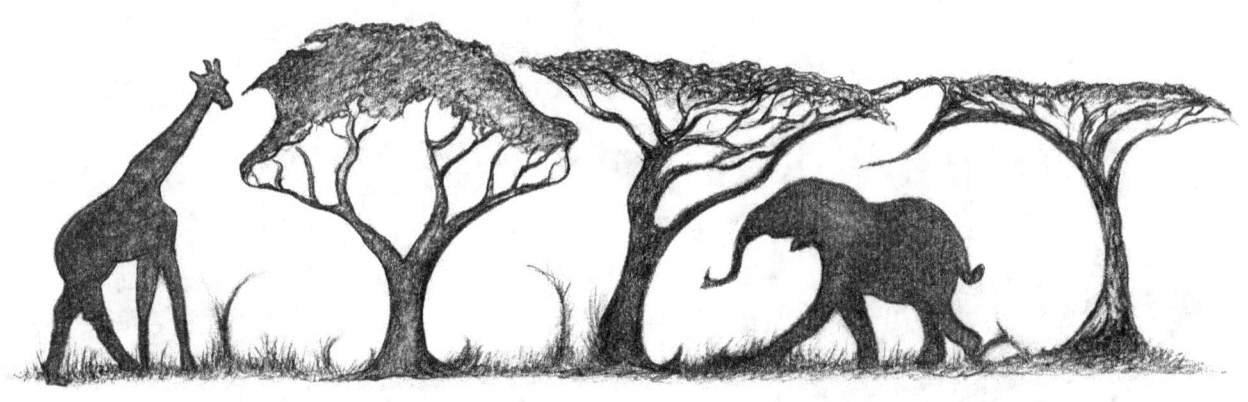

Positive Space – is best described as the areas in a work of art that are the subjects, or areas of interest. For example, in this illusion, do you see three hidden rabbits or just an elephant and a giraffe? If you are seeing an elephant and a giraffe then you are seeing the black areas as the positive space. The white areas become the negative space. If you are seeing three rabbits, then you are seeing the white areas as the positive space and the black areas as the negative space.

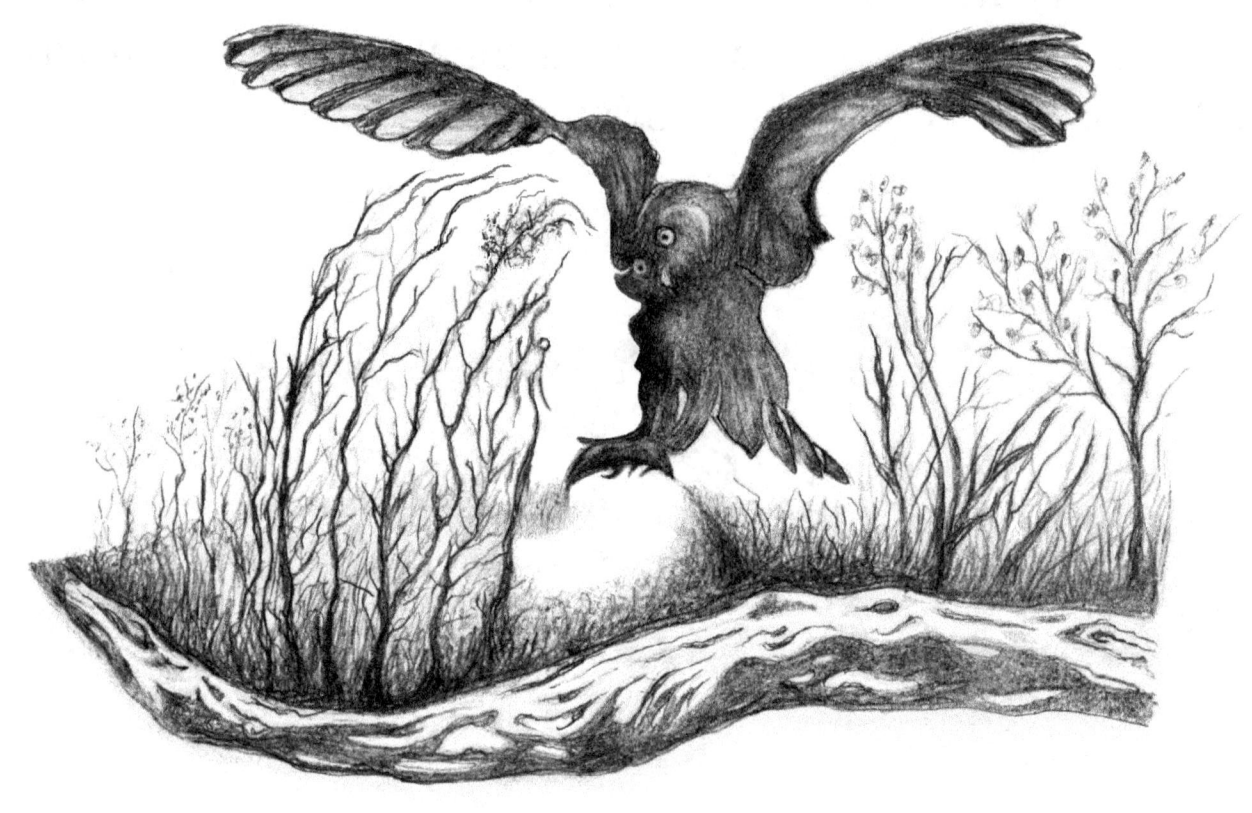

Here is a good example of a negative and positive space illusion. Do you see a beautiful woman or an owl?

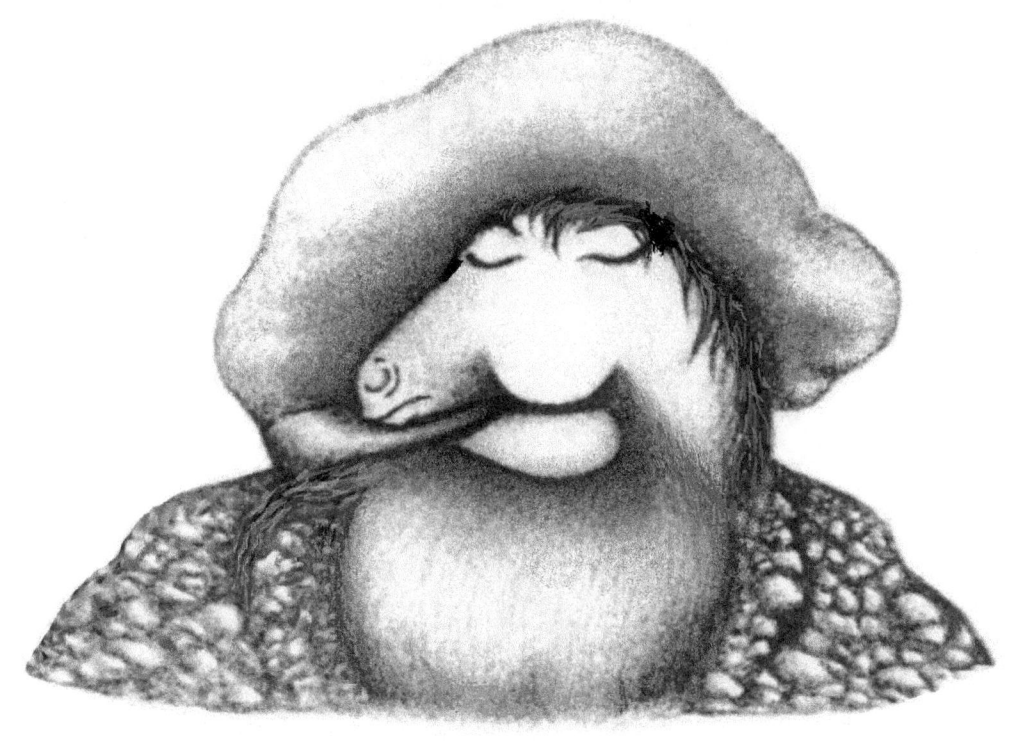

Do you see a bearded man with a pipe in his mouth or a horse? If you missed the horse, check again in the center of the illusion.

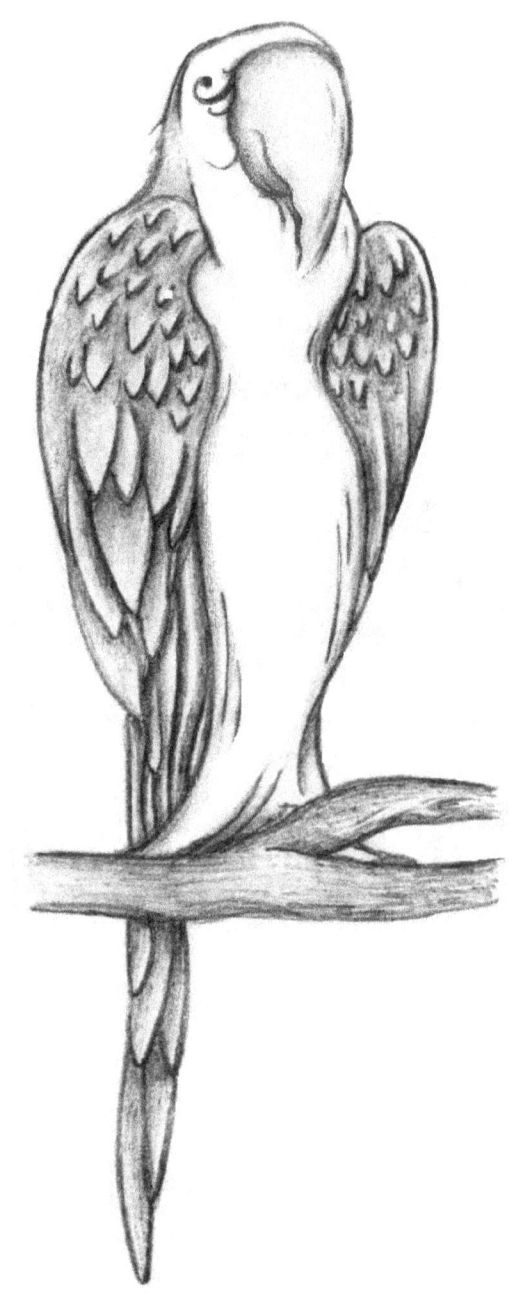

Can you see a woman wearing a long dress with her arm over her head or just a parrot standing on a branch?

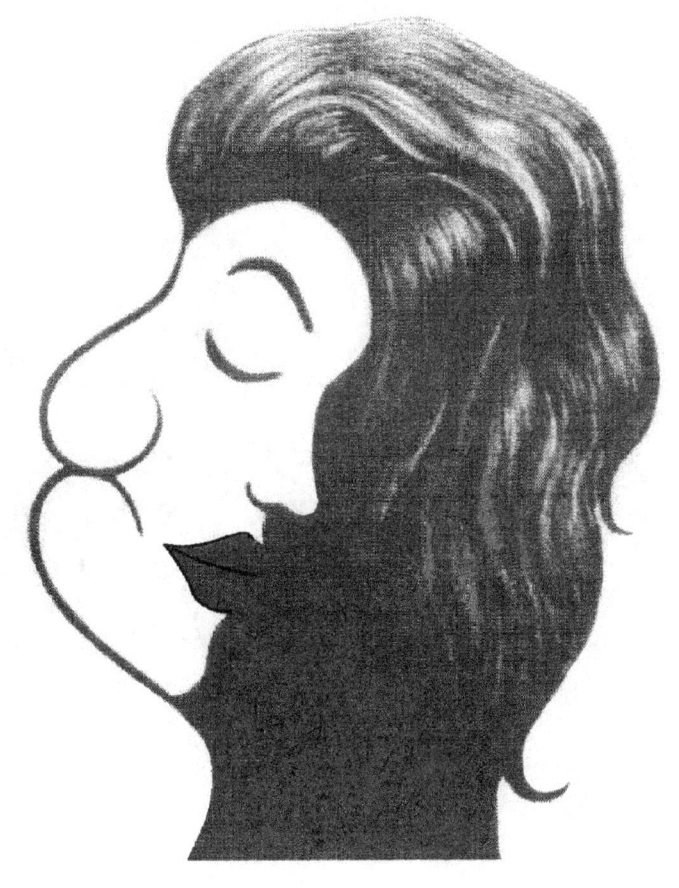

A creative ambiguous illusion where you can see a face facing to the left or a woman looking over her shoulder.

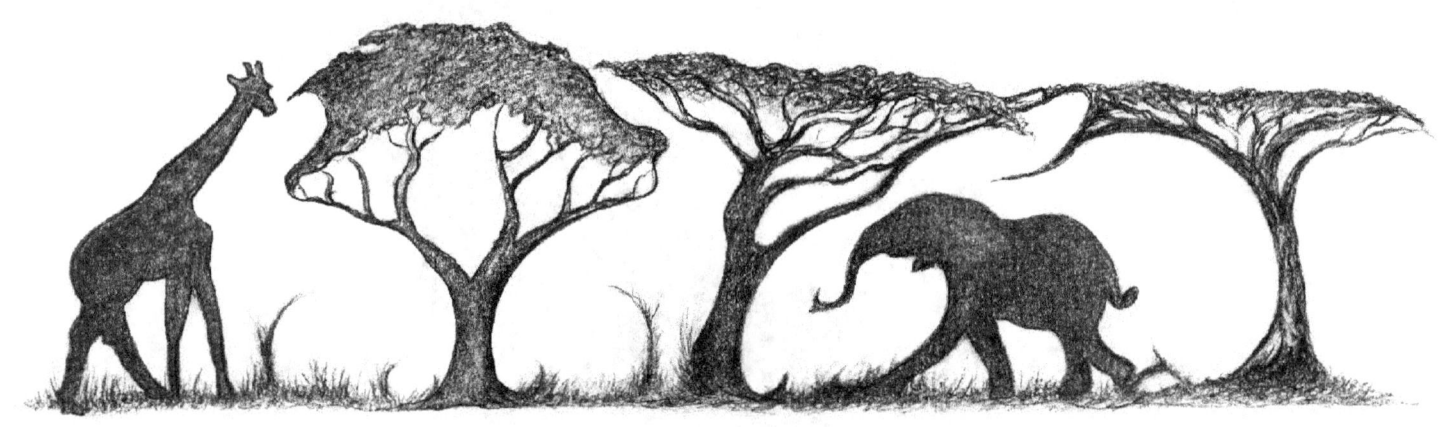

You can obviously see an elephant and a giraffe, but can you see the three hidden rabbits?

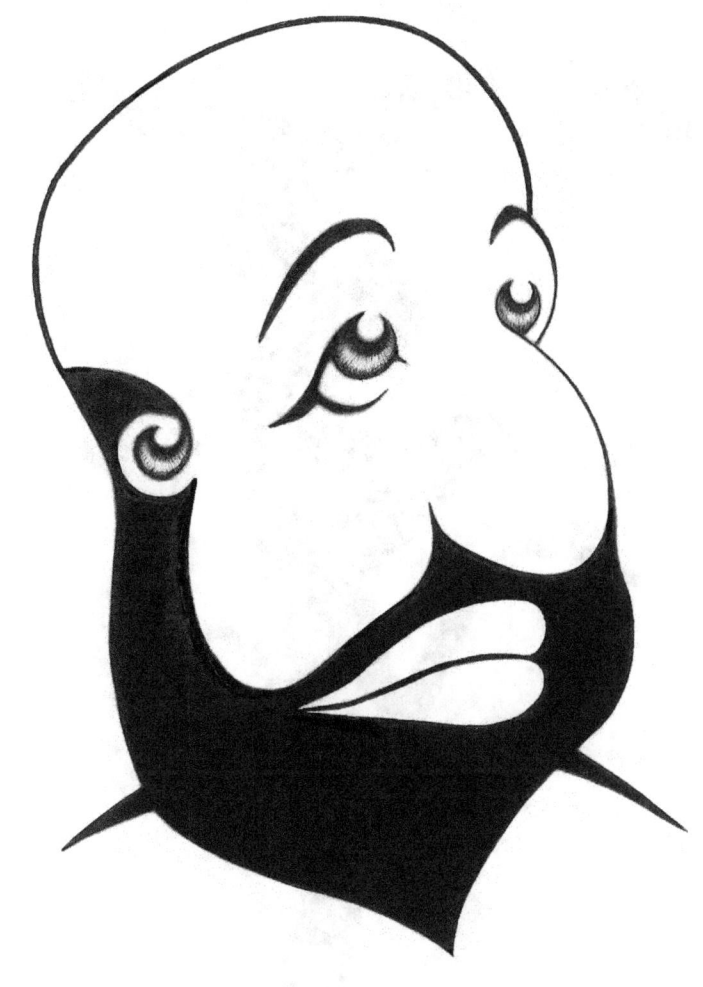

Do you see both expressions? Mad and Sad. (See solution on page 56).

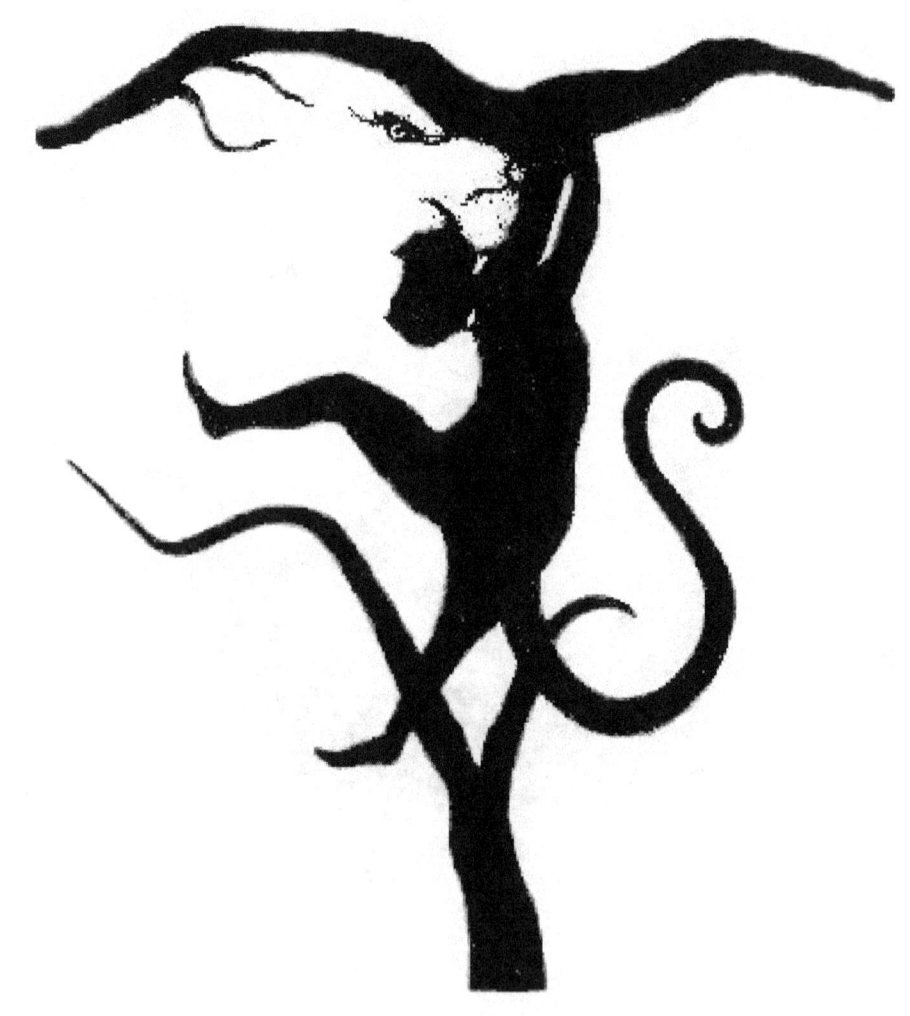

Here's a creative negative space illusion of an angry lion or a cheerful monkey swinging from a tree branch. They both occupy the same space.

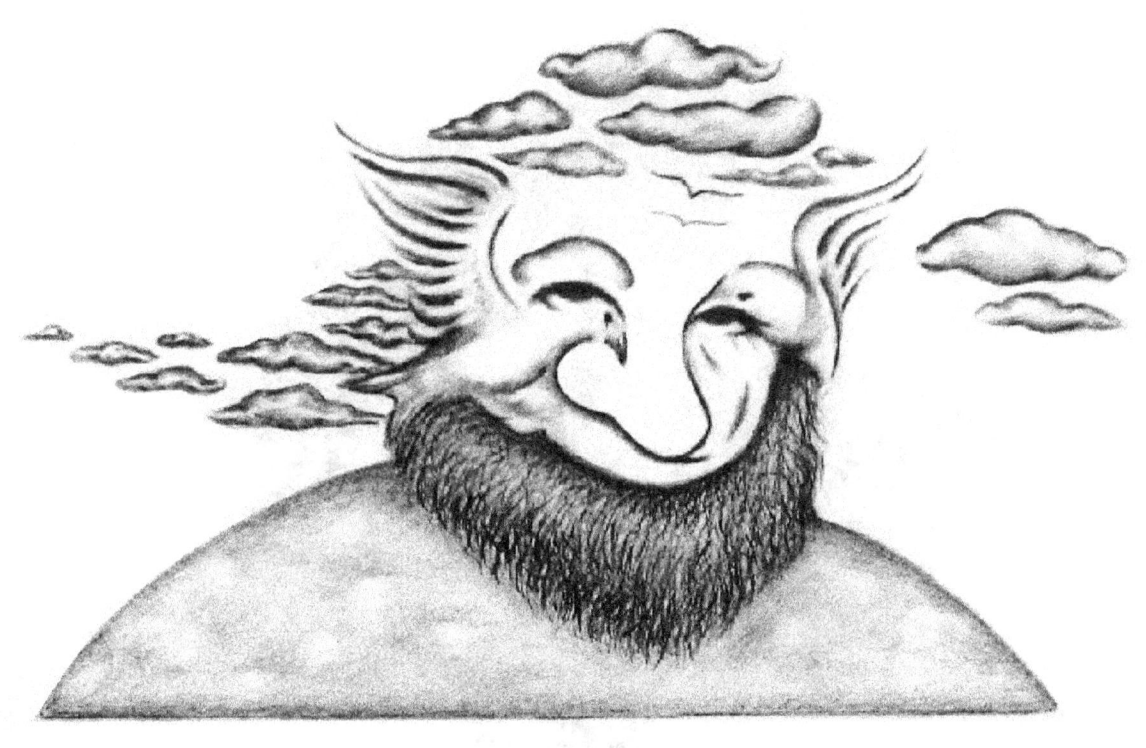

Do you see a bearded elf or just two birds in a nest?

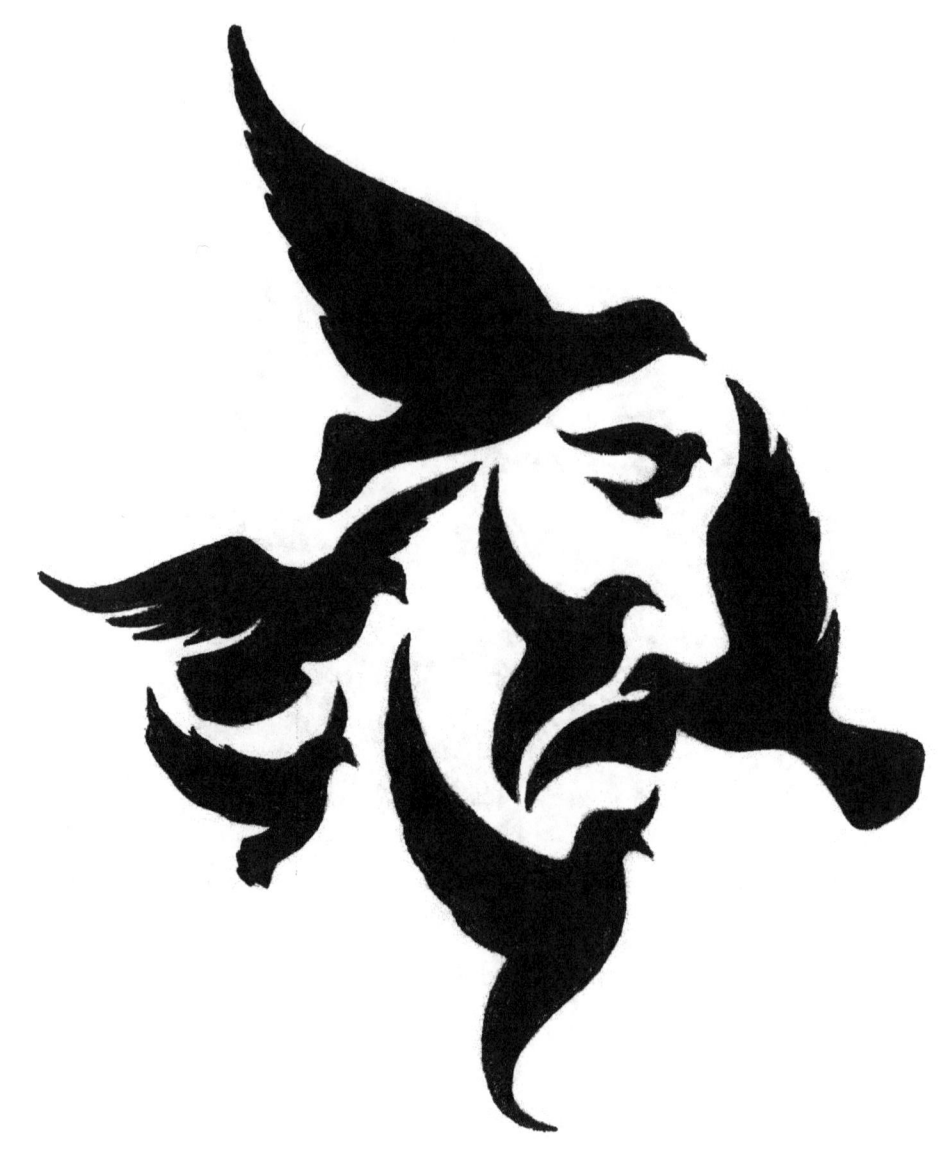

Flying doves or an image of a face?

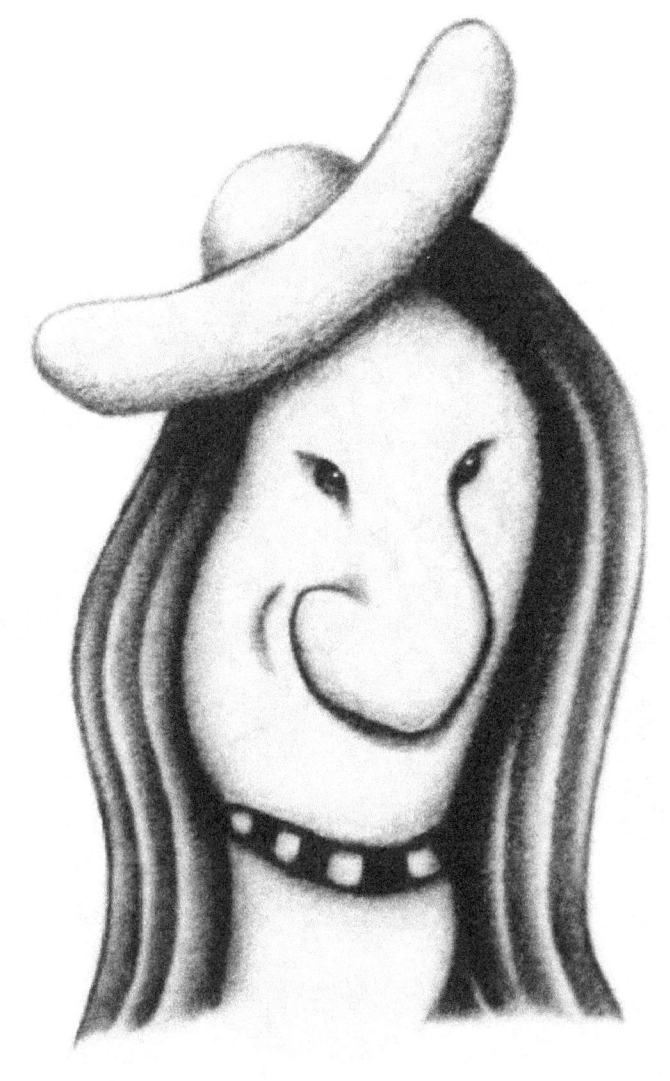

Clearly you can see a wicked old lady, but can you see a Mexican man wearing a poncho and taking a siesta?

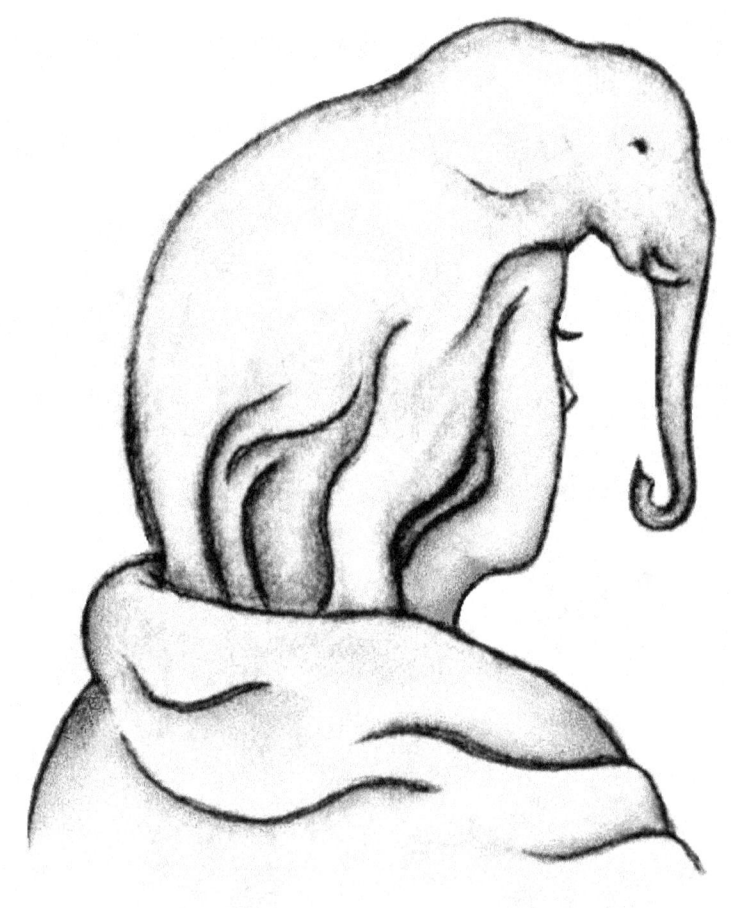

Do you see an elephant standing on a large boulder or a girl with a bathrobe?

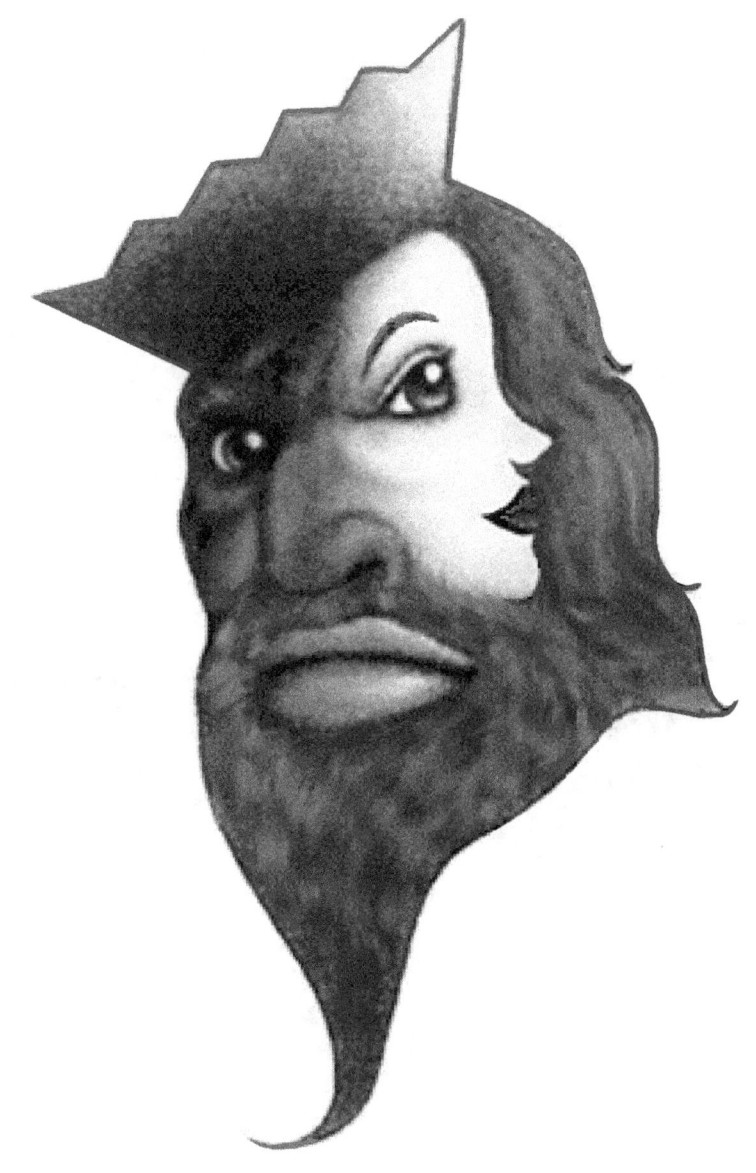

See the two royal family members?

In this ambiguous drawing a rabbit and a duck can be seen. There have been other earlier known versions.

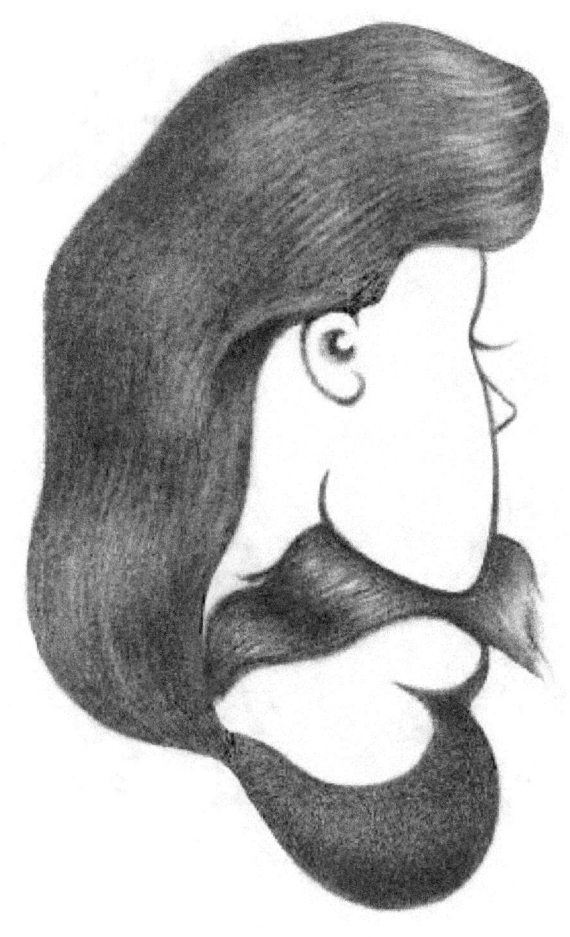

Do you see a beautiful woman looking away from you or a hairy man with a mustache and a big nose?

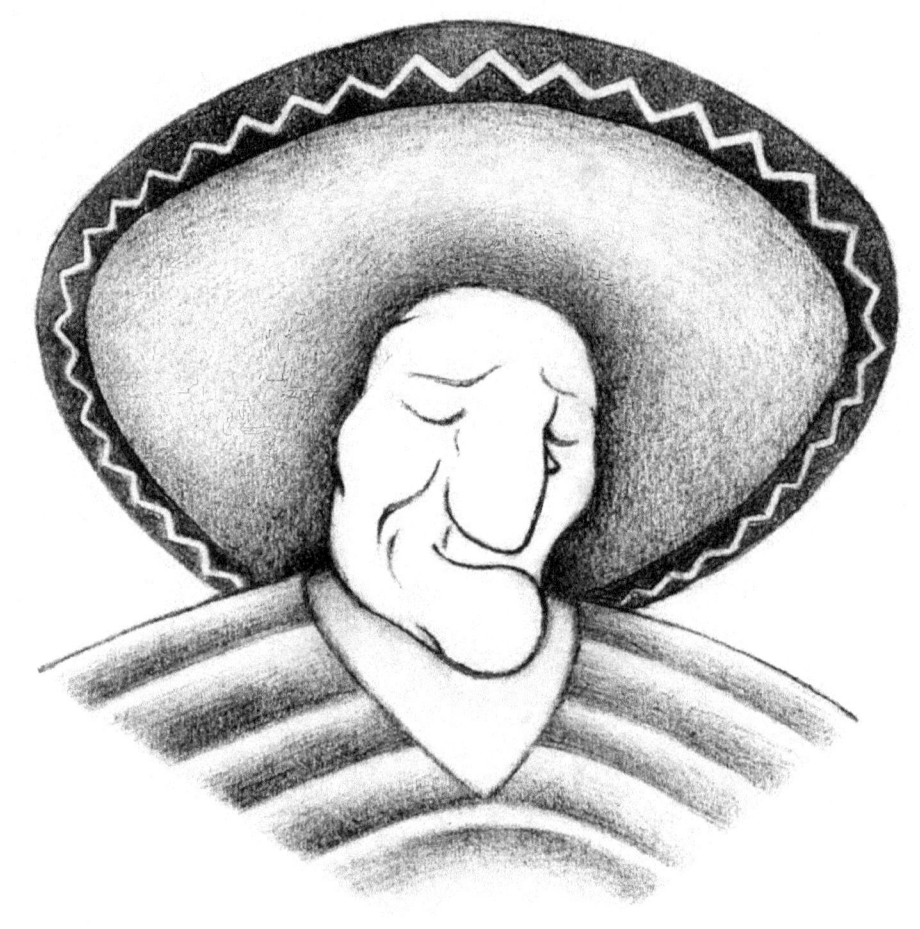

Do you see an old man with a sombrero or a young woman?

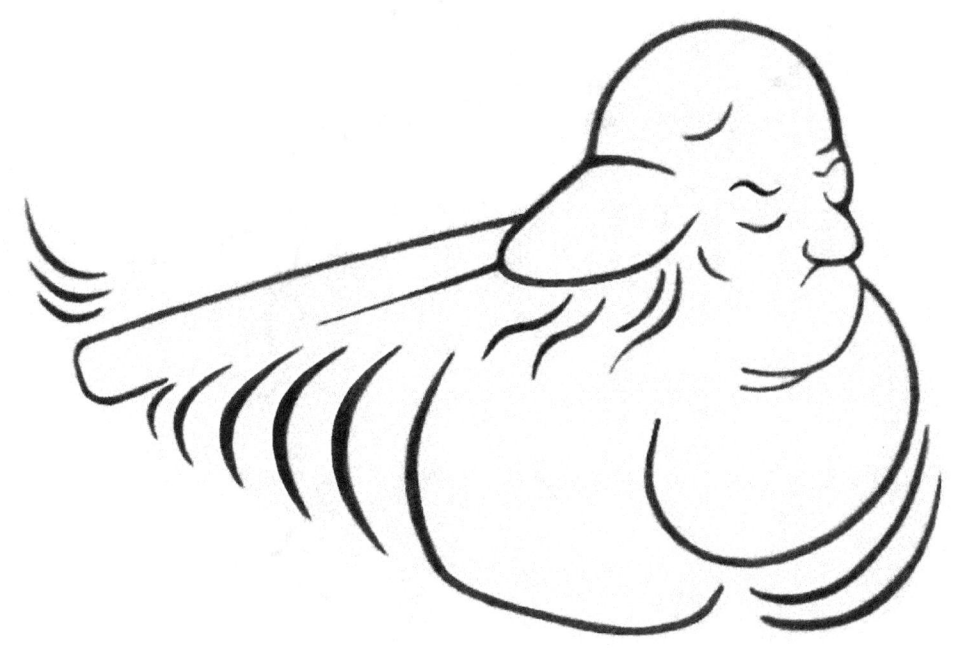

In this illusion you can see a duck, but can you see a baseball player swinging a bat?

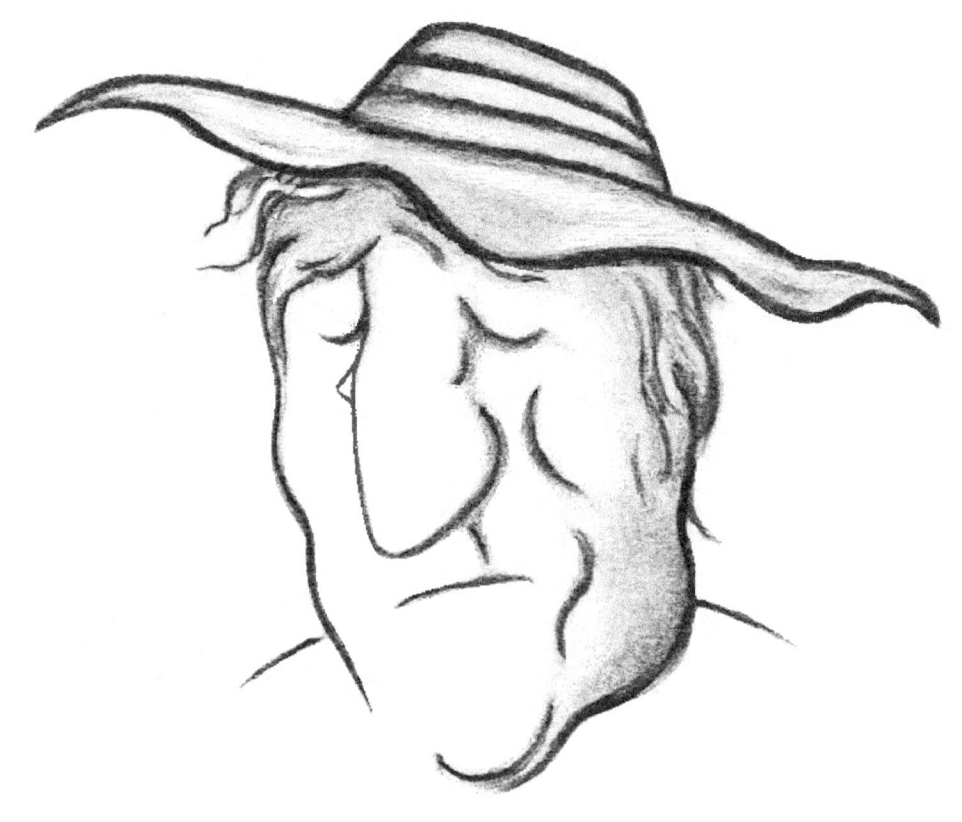

Can you see a man with a hat or a woman with a hat?

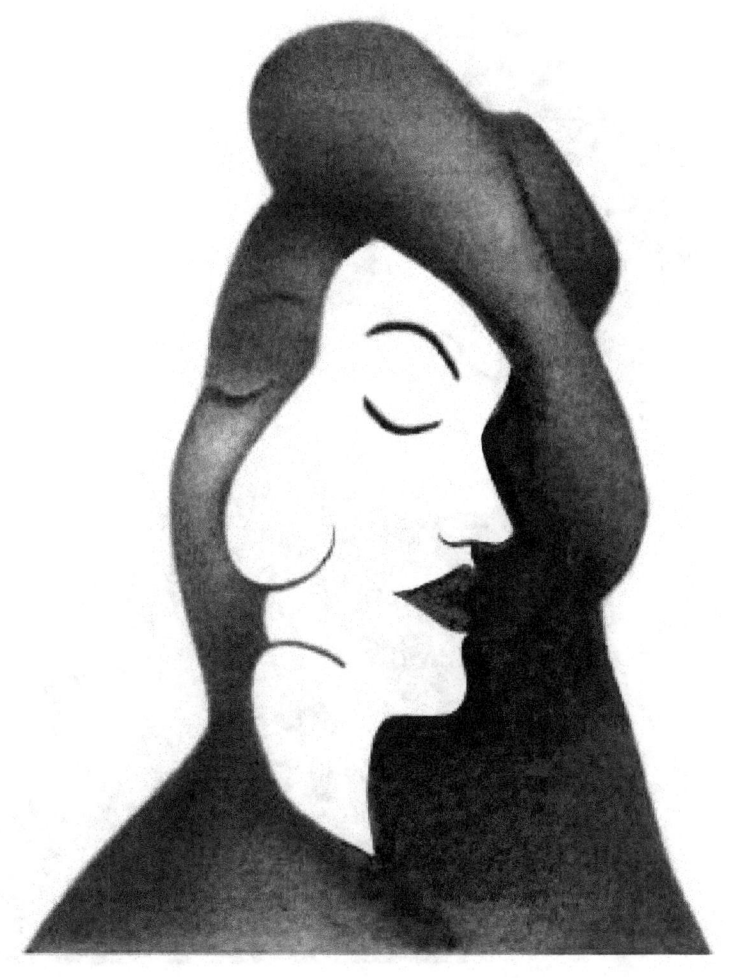

Can you spot all three faces?

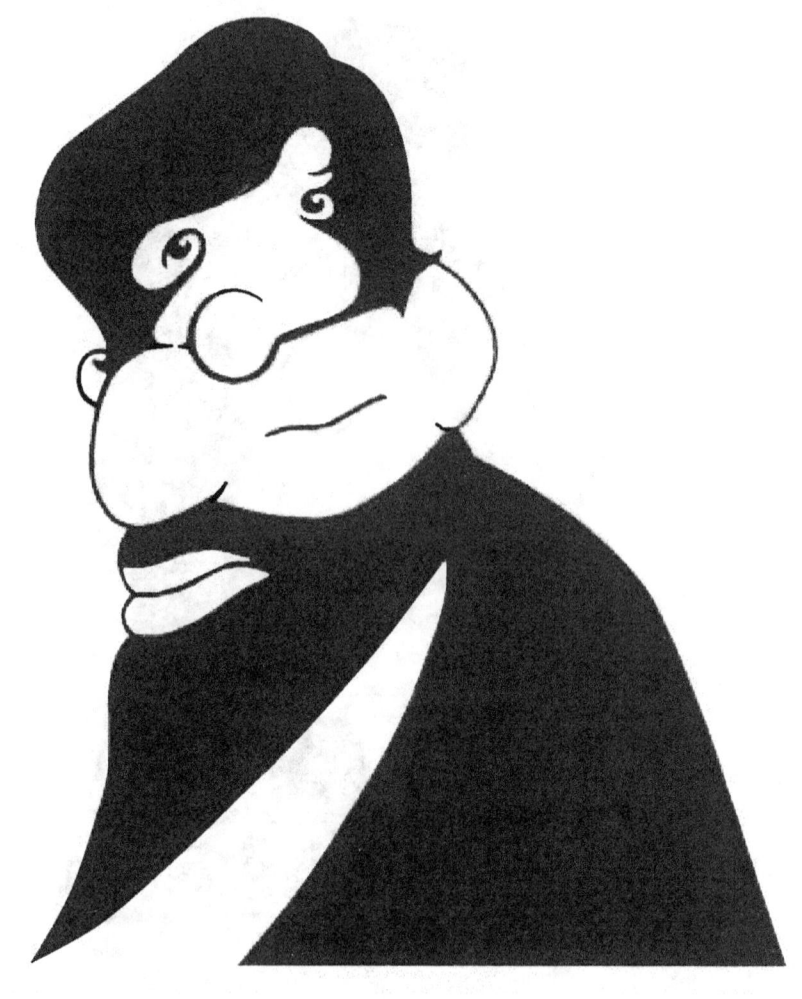

Can you see both faces? You really need to see this image with concentration to find the faces. Look closely, one has a long beard and the other has large cheeks.

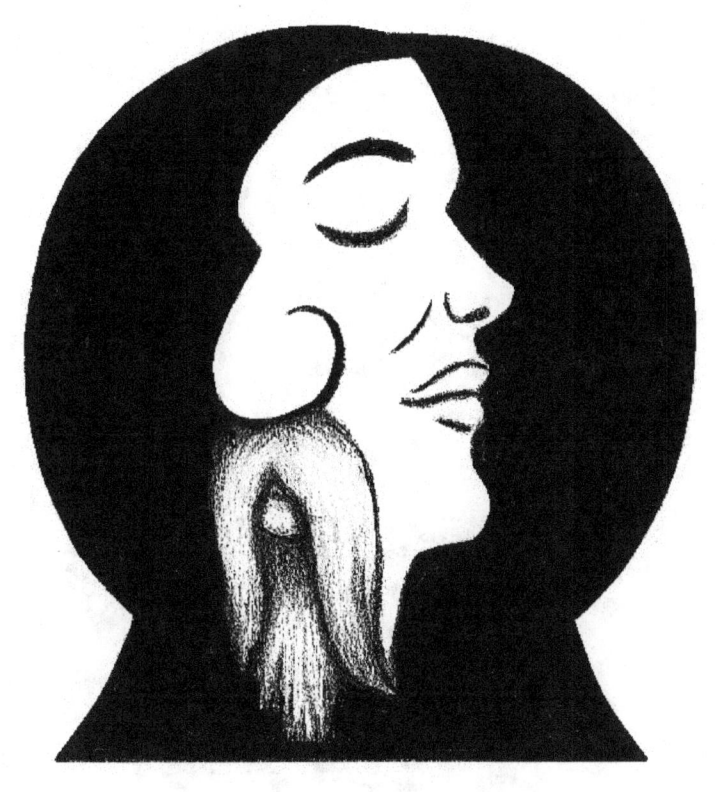

Can you spot the person or persons? Do you see a male or female, or both? Both are shown in this ambiguous image.

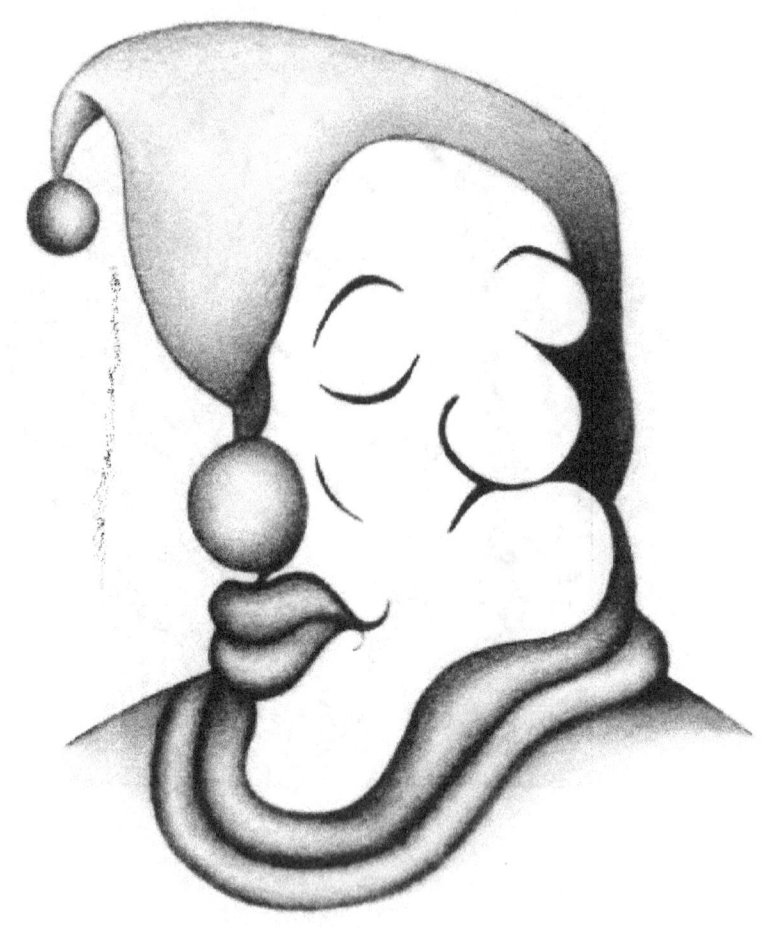

Depending on how you look at this image, you will either see a clown or a man with a nightcap.

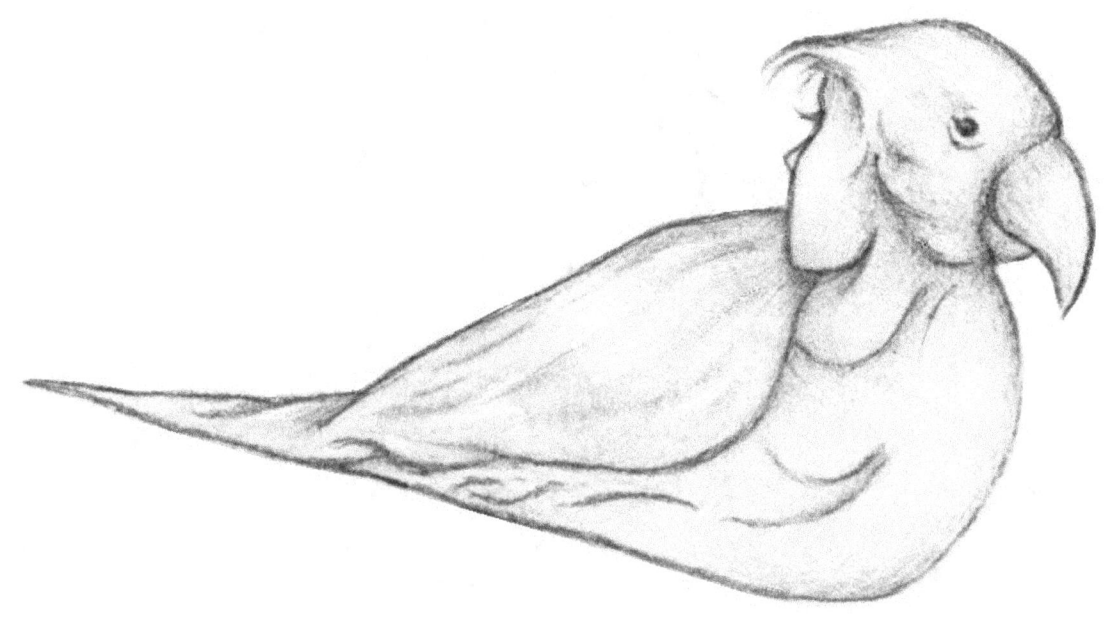

What do you see in this image? Do you see a bird or a girl with a blanket over her shoulder?

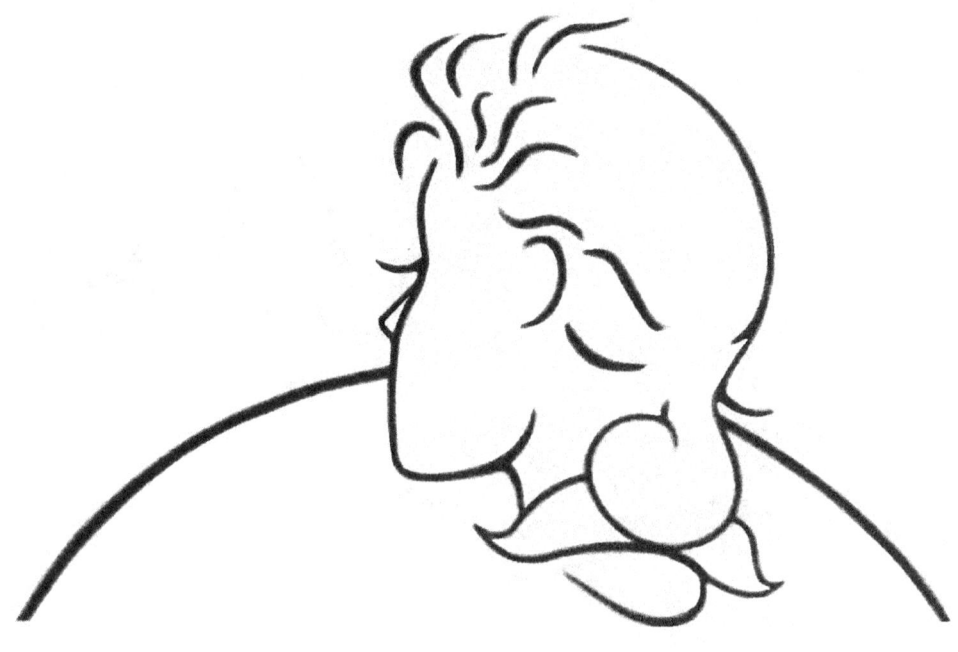

Can you see both faces? The girl seems to be looking out into the sunset while the old man seems to be slouched over and sleeping.

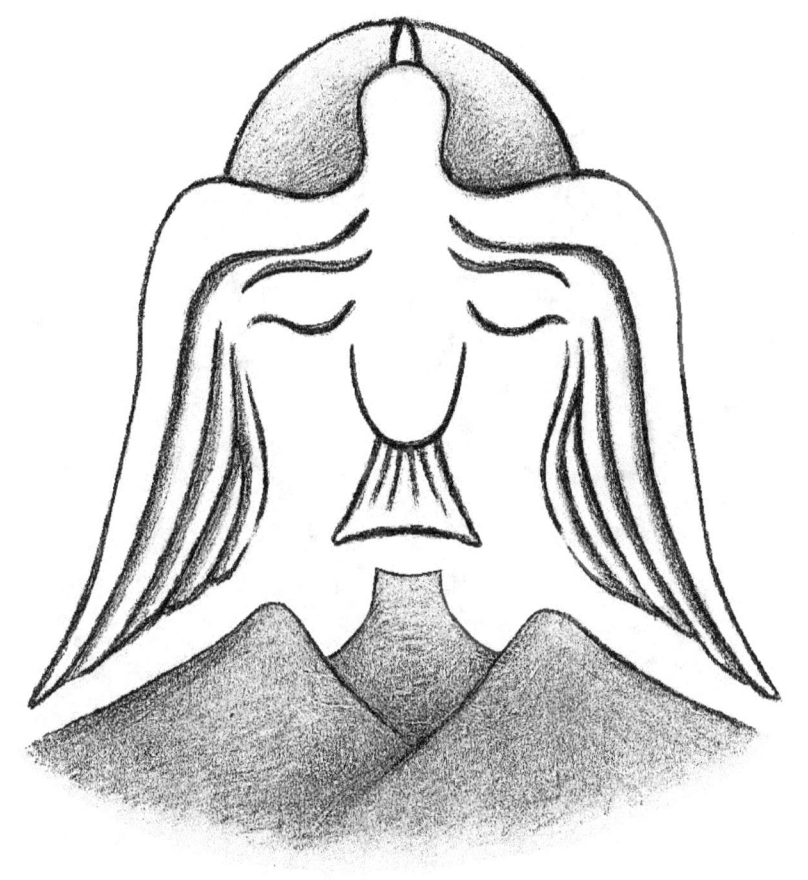

Here you can see a bird flying toward the sun and over the mountains to form a man's face.

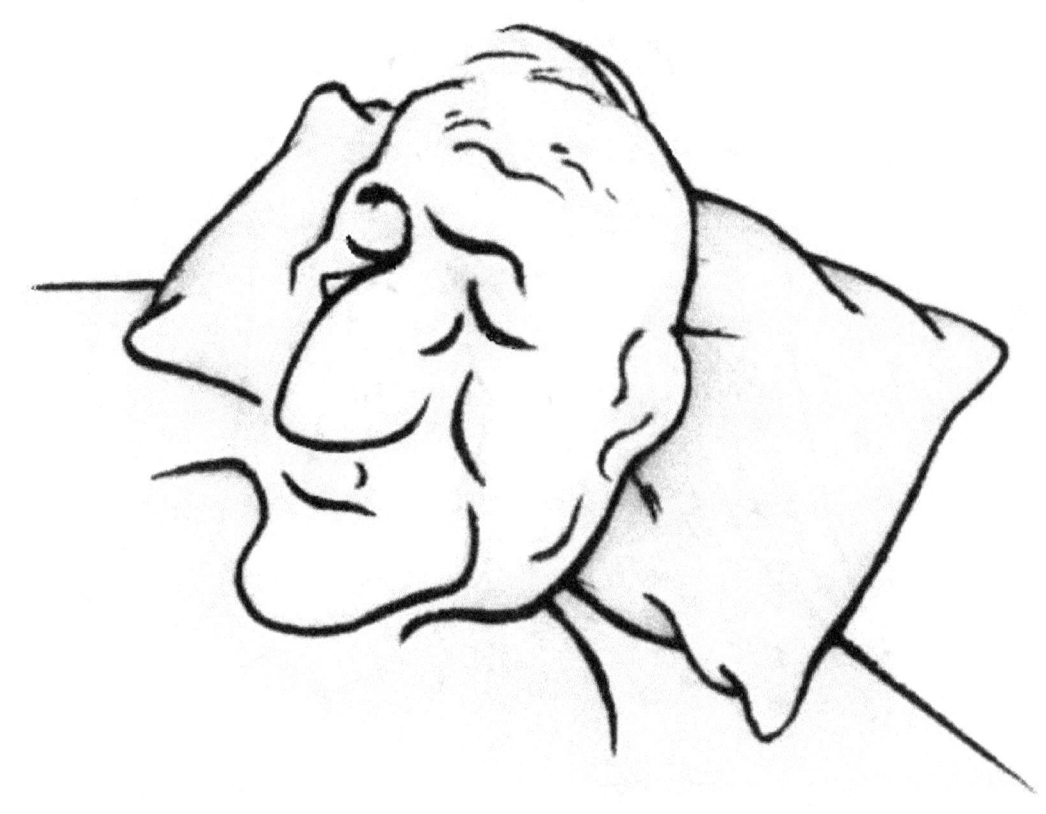

You really have to look closely at this deceptive ambiguous image to see the woman sleeping. (See solution page 56).

In this section of the book you will come across some great examples of classical optical illusions that date as far back as the mid 1700's.

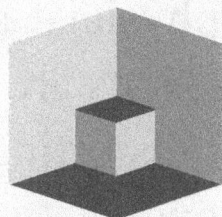

Optical Illusions – *A visual perceived image that is deceptive or misleading.*

Cognitive Illusions – can be defined as the viewer's knowledge and assumptions about the world, or unconscious inferences. It was first suggested in the 19th century by the German physicist and physician Hermann Helmholtz. Cognitive illusions are commonly divided into ambiguous illusions, distorting illusions, paradox illusions, or fiction illusions.

Ambiguous Illusions – are pictures or objects that elicit a perceptual switch between the alternative interpretations. The Necker Cube and Rubin Vase are well-known examples.

Distorting or Geometric Optical Illusions – are characterized by distortions of size, length, position or curvature. A perfect example is the Café Wall illusion and Ponzo Illusion.

Paradox Illusions – are generated by objects that are paradoxical or impossible, such as the Penrose Triangle or impossible staircase, for example, in M.C. Escher's Ascending and Descending and Waterfall.

Fictions – are when a figure is perceived even though it is not in the stimulus.

A little history on Optical Illusion

Long ago people didn't know if their brain was playing tricks on them or if their eyes were playing tricks on them because they didn't know anything about optical illusions. Many were trying to explain how optical illusions worked, but failed. Epicharmus and Protagoras are the two people who invented optical illusions, which they both lived around 450 B.C.

Epicharmus – believed that our senses (seeing, hearing, smelling, tasting, and touching) deceive us and present an optical illusion. Epicharmus exact words were, "The mind sees and the mind hears. The rest is blind and deaf".

Protagoras – another Greek philosopher, had a different explanation on this subject. Protagoras didn't believe Epicharmus. He believed that our environment that was fooling our senses.

Aristotle – Greek philosopher and Scientist (350 B.C.), said both Epicharmus and Protagoras were both right and wrong. He said our senses can be trusted, but they can be easily fooled.

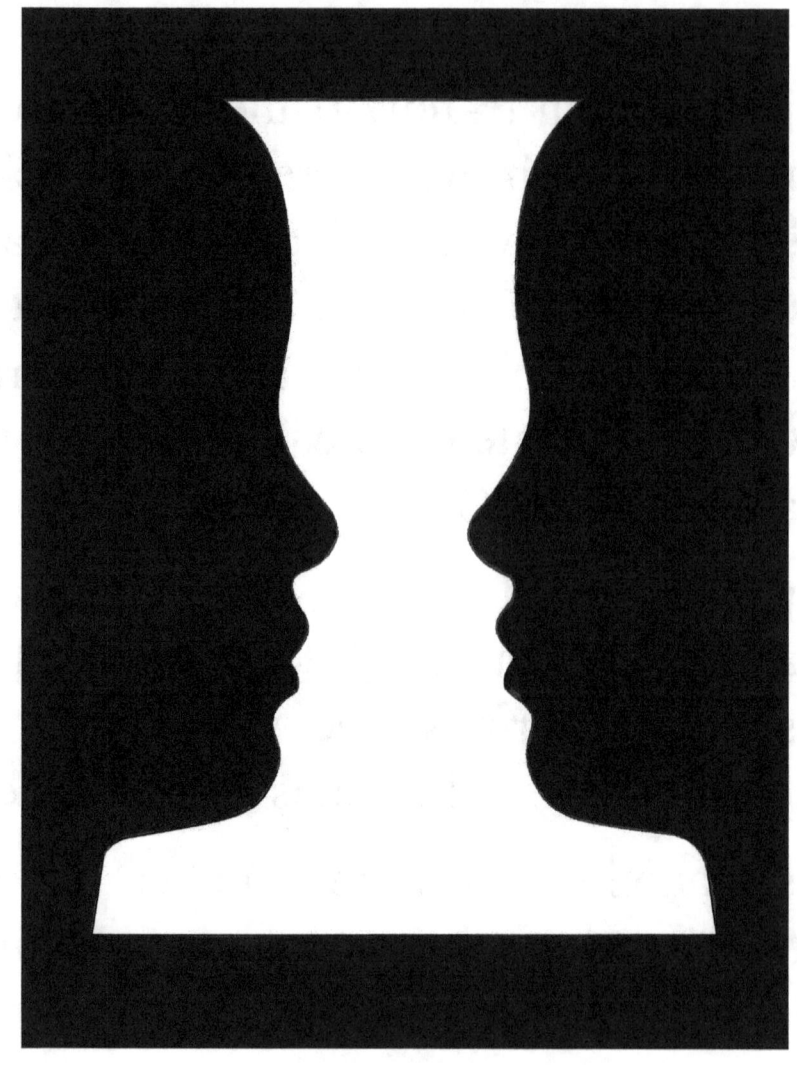

Do you see a Holy Cup or two facial profiles? A famous example of the Rubin's Vase developed around 1915 by the Danish psychologist Edgar Rubin.

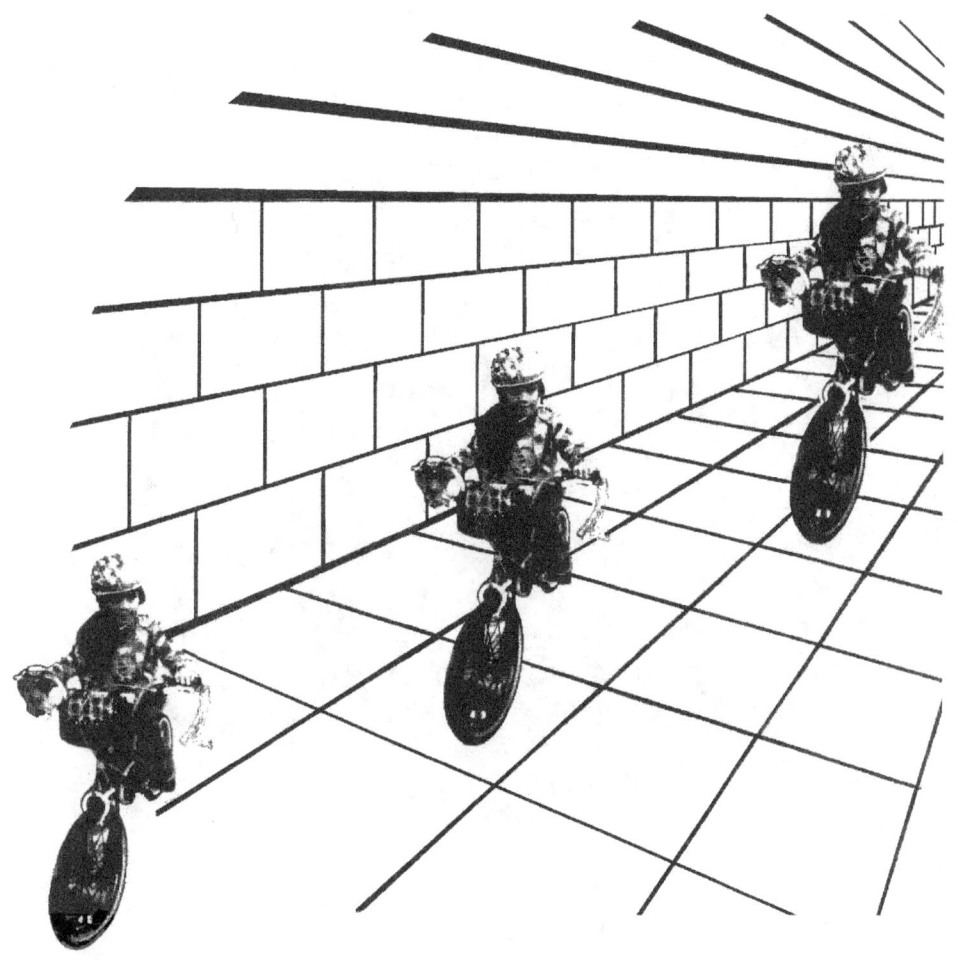

In this Depth Perception illusion, the lines on the floor, wall and ceiling in this image tell us that we are looking into the distance. The young girl riding her bicycle furthest back appears to be larger but they are all the same size.

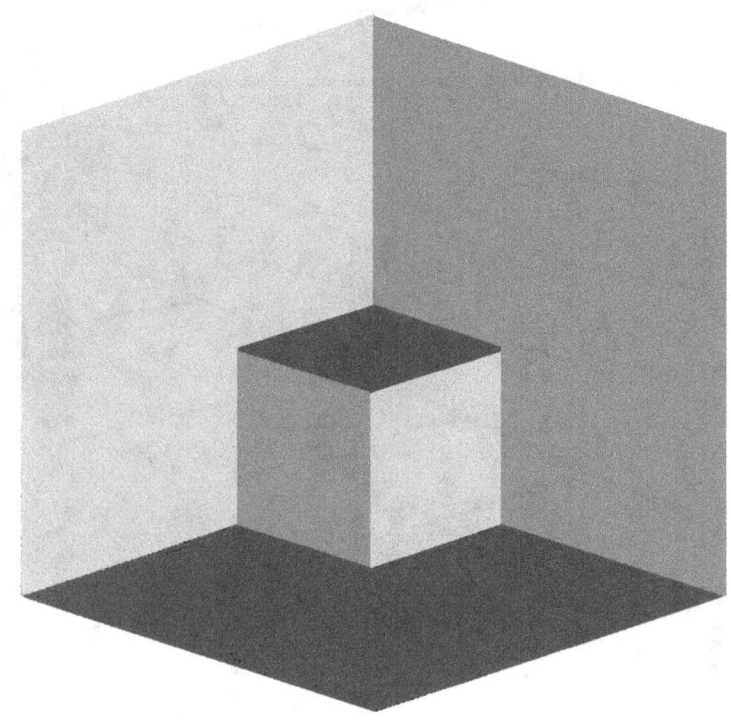

Do you see a cube with a missing corner or a room with a cube in the corner?

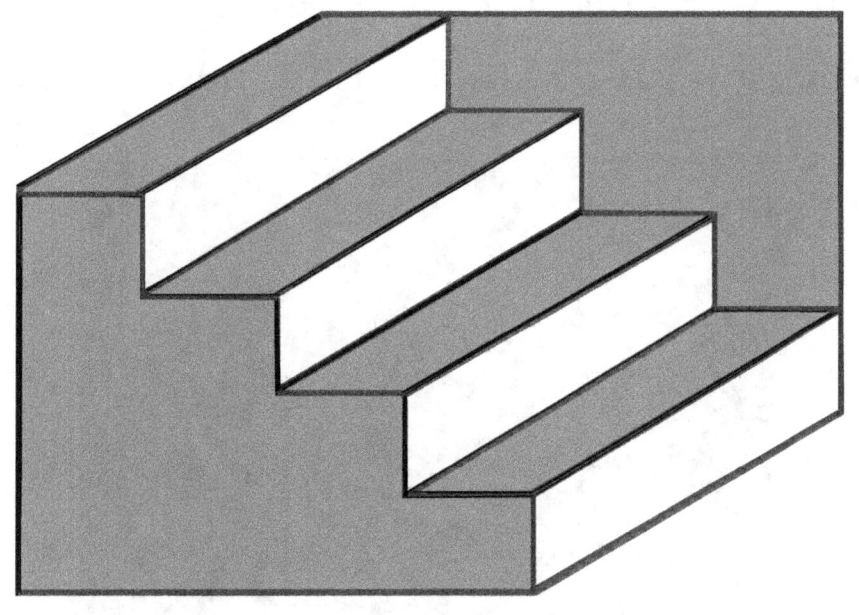

Schroeder stairs, also called "Schouten's staircase", is an ambiguous figure that depicts two different staircases at the same time, one going up from right to left, the other turned upside down.

Can you find the mistakes in this original engraving? For example, the crossed fishing lines, the foreshortened sheep, the man discharging his gun 'point blank' into the bridge, the sinking church, the bird on the tree and the woman in the foreground lighting the pipe of the man in the background.

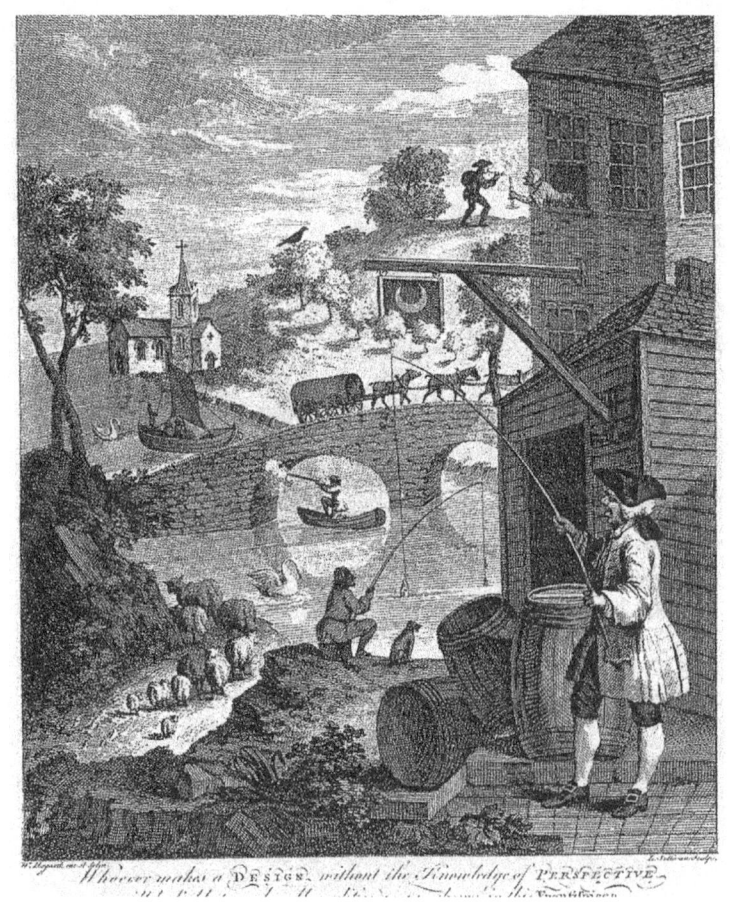

Satire on False Perception – is the title of this engraving produced by William Hogarth in 1754 for his friend John Joshua Kirby's pamphlet on linear perceptive.

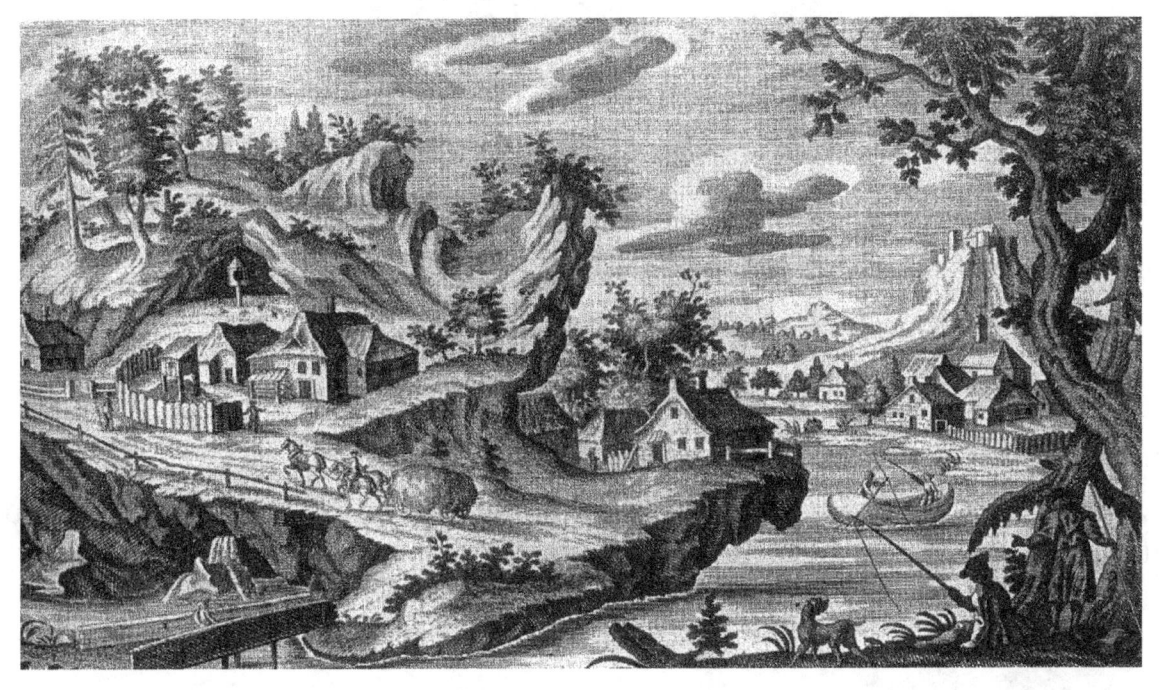

(Johann Martin Will engraving from 1780.)

Can you find a hidden face in this landscape?

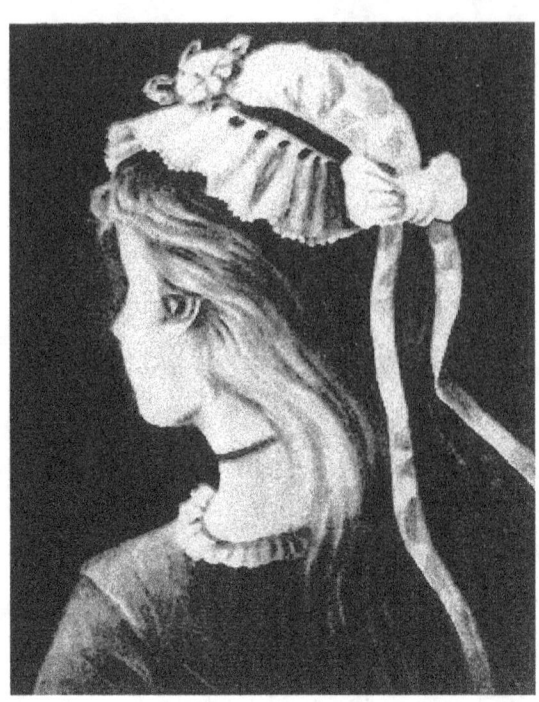

Hill is always credited for this picture (shown above), but he did not invent it. An anonymous German postcard from 1888 depicts the image of an ugly witch or a young girl in its earliest form.

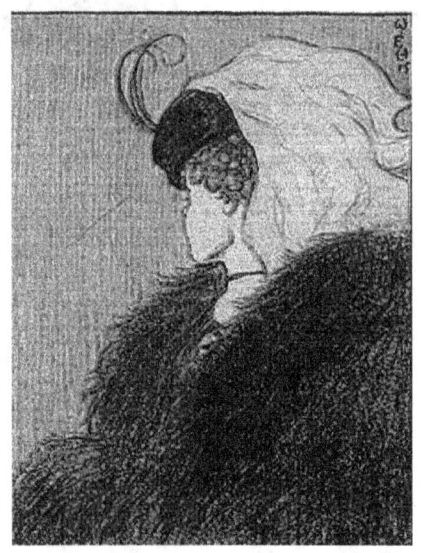 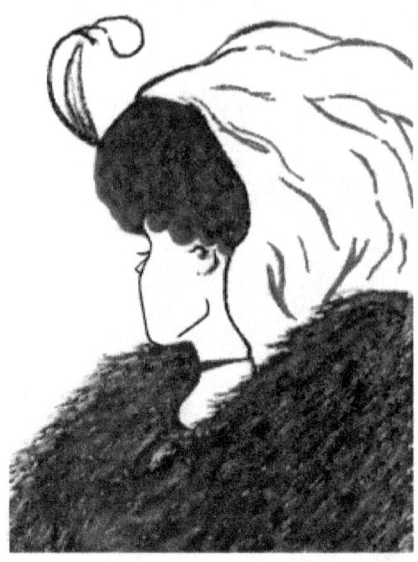

"My Wife and My Mother-in-Law" created by W. E. Hill in 1915. What is the young woman's chin is the tip of the old lady's nose.

The "*Jastrow Illusion*" was first discovered in 1889 by American psychologist, Joseph Jastrow.

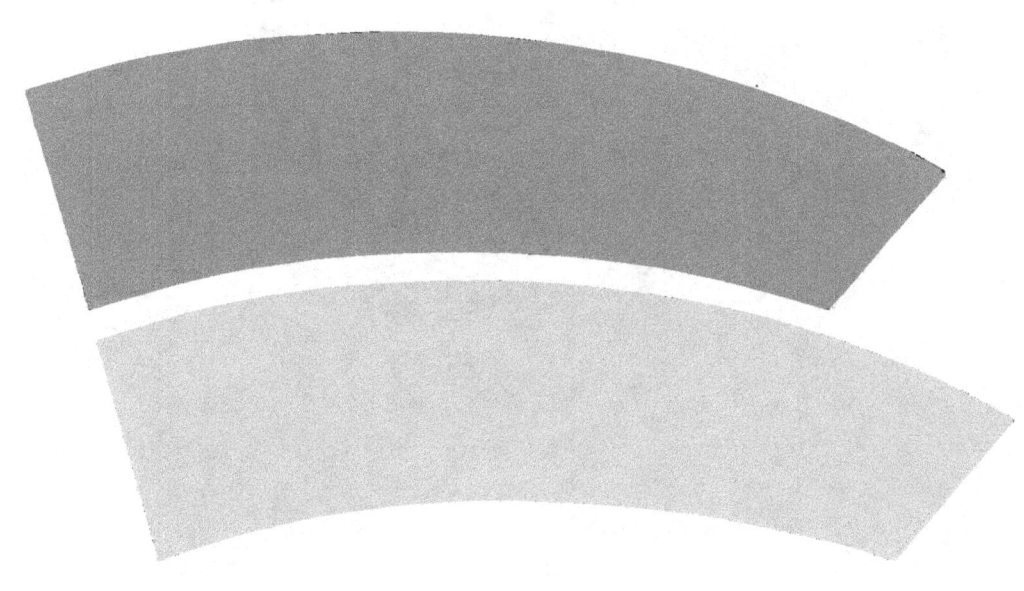

Although the lower one appears longer, both figures are identical in size.

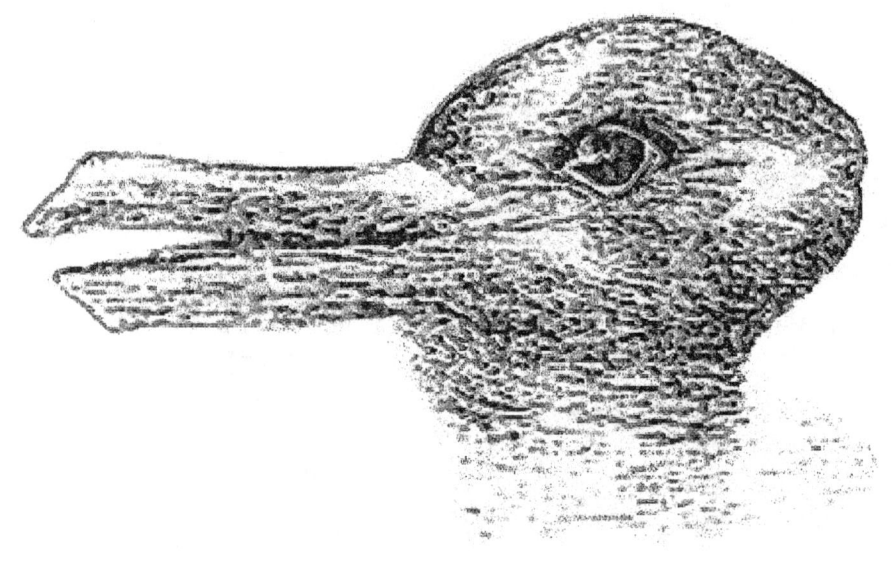

Here's another ambiguous illusion by Joseph Jastrow in which the brain switches between seeing a rabbit and a duck.

Here's an example of a well-known illusion called the "*Ebbinghaus Illusion*" or "*Titchener Circles*". Named for its discovery, the German psychologist Hermann Ebbinghaus (1850-1909).

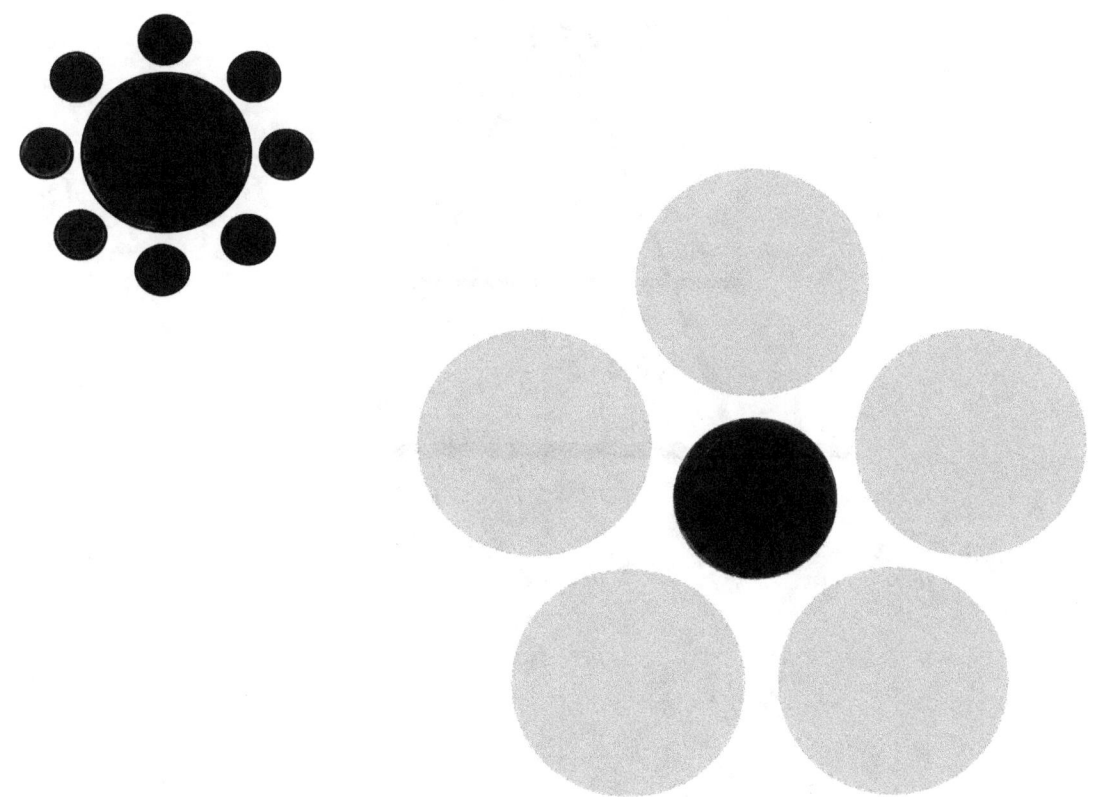

In this illusion, the central circle surrounded by large circles appears to be smaller than the circle surrounded by small circles, but are both the same size.

Depth Perceptual Illusion:

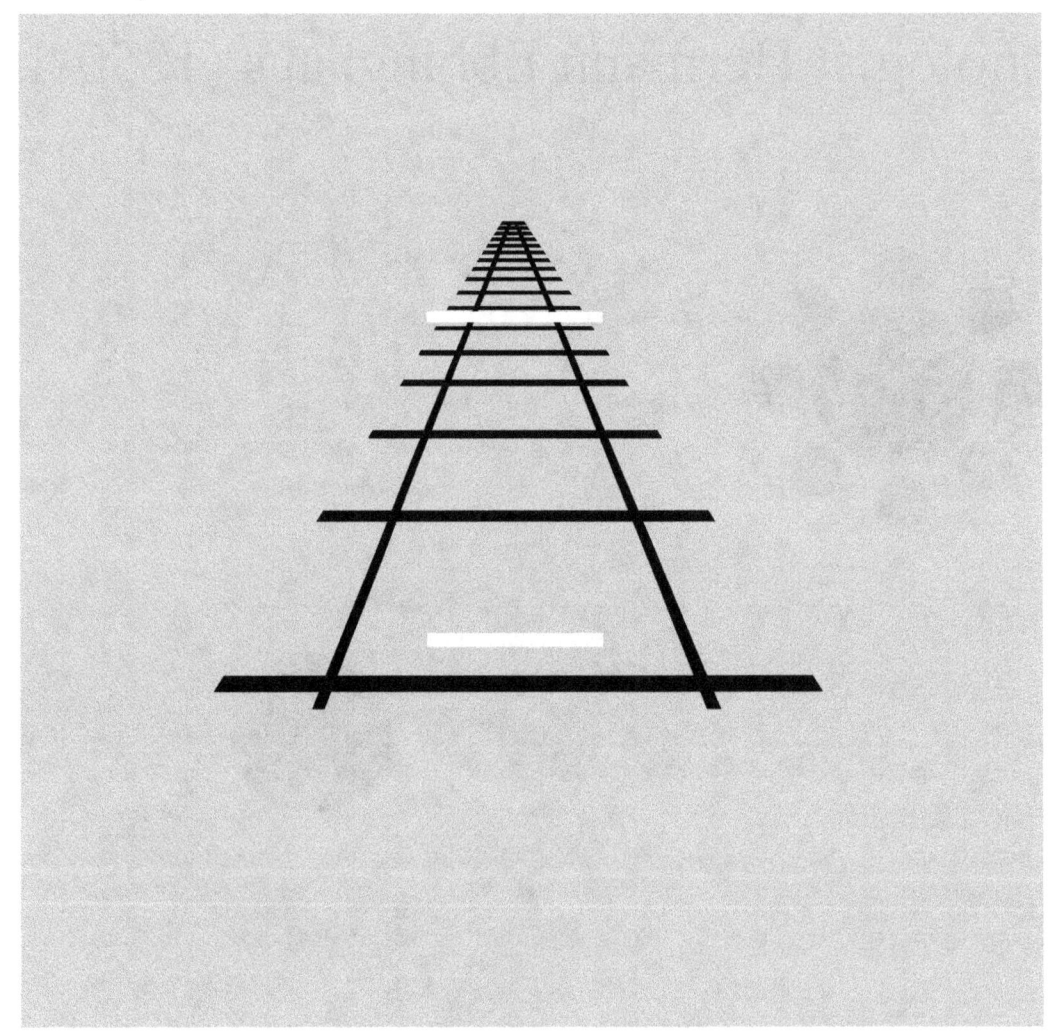

Which of the white lines is longer? They're both the same length. This image uses parallel and non-parallel lines to distort your perception.

This is a classical distorting illusion called "*The Zöllner Illusion*". It was named after its discovery, German astrophysicist Johann Karl Friedrich Zöllner.

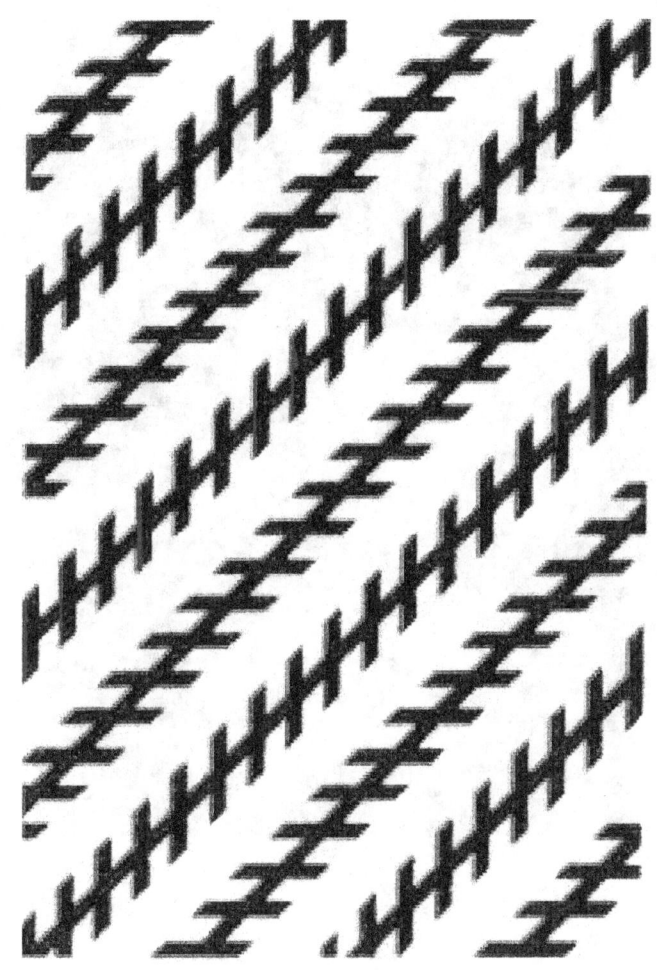

In this illusion the black lines appear to be unparalleled, but in reality they are.

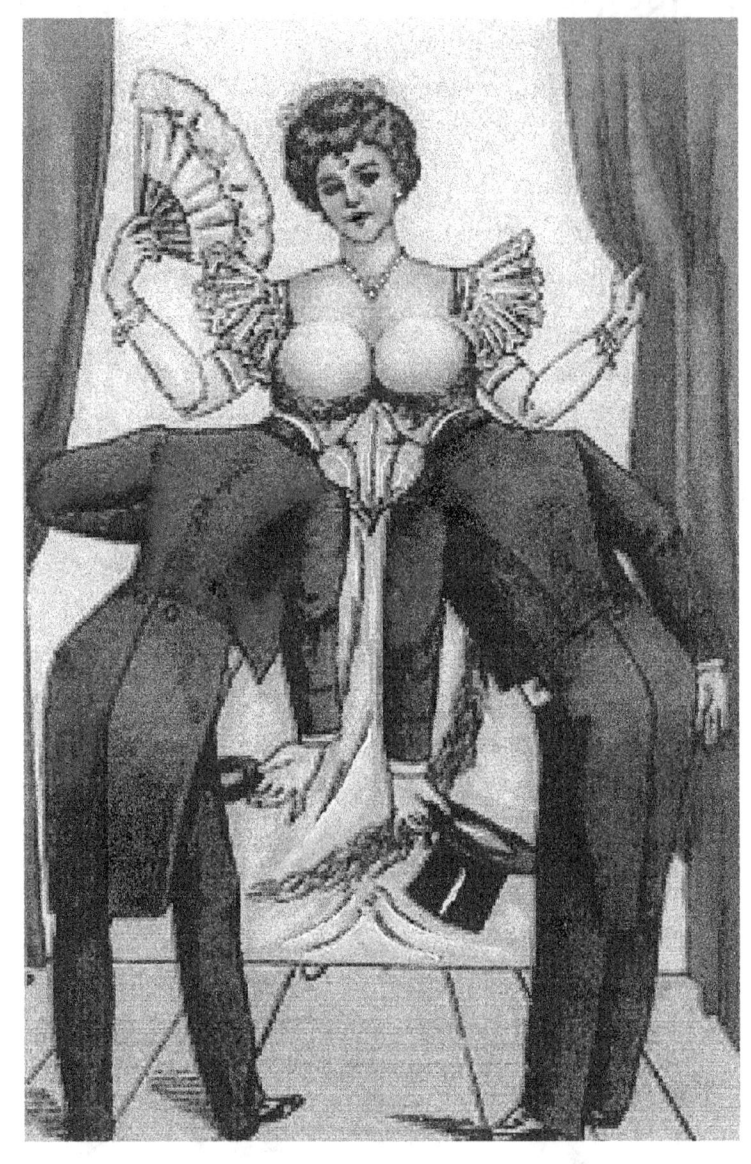

Do you see two bald-headed gentlemen or a large-chested lady?

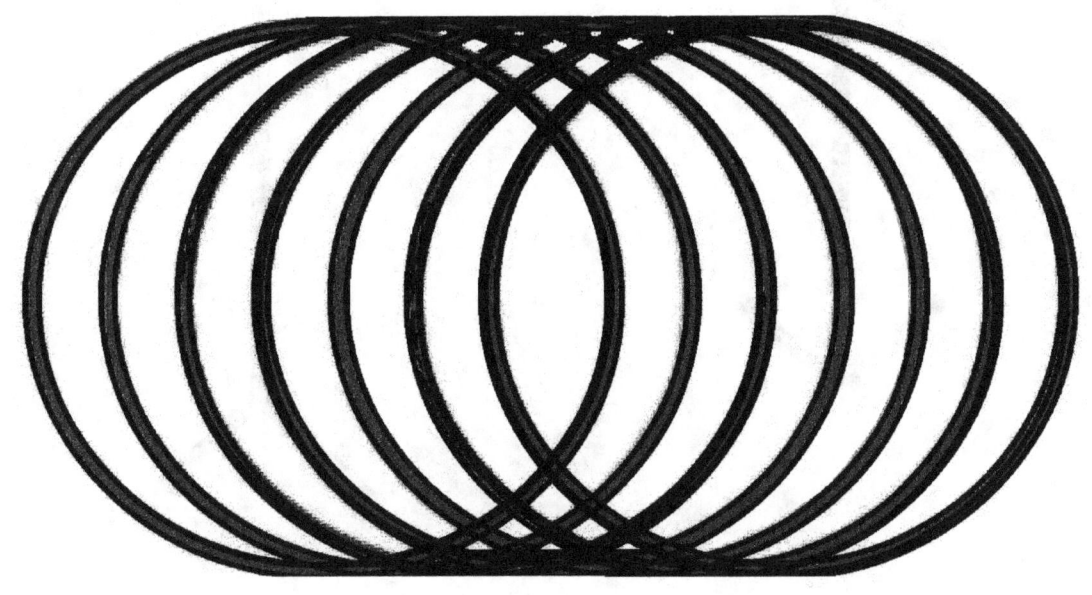

Are you looking at this cylinder from left to right or right to left?

Müller-Lyer Illusion:

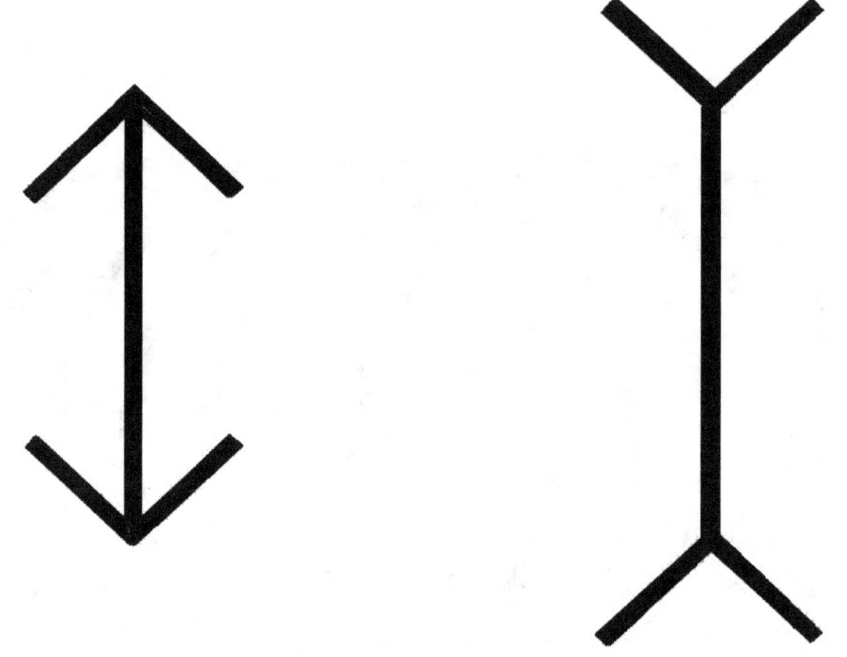

Arrow Junctions Fork Junctions

Lines with arrow junctions attached to the ends are perceived as shorter and lines with attached fork junctions are perceived as longer. Origin after Franz-Carl Müller (1857-1916), German sociologist, who described the illusion in 1889.

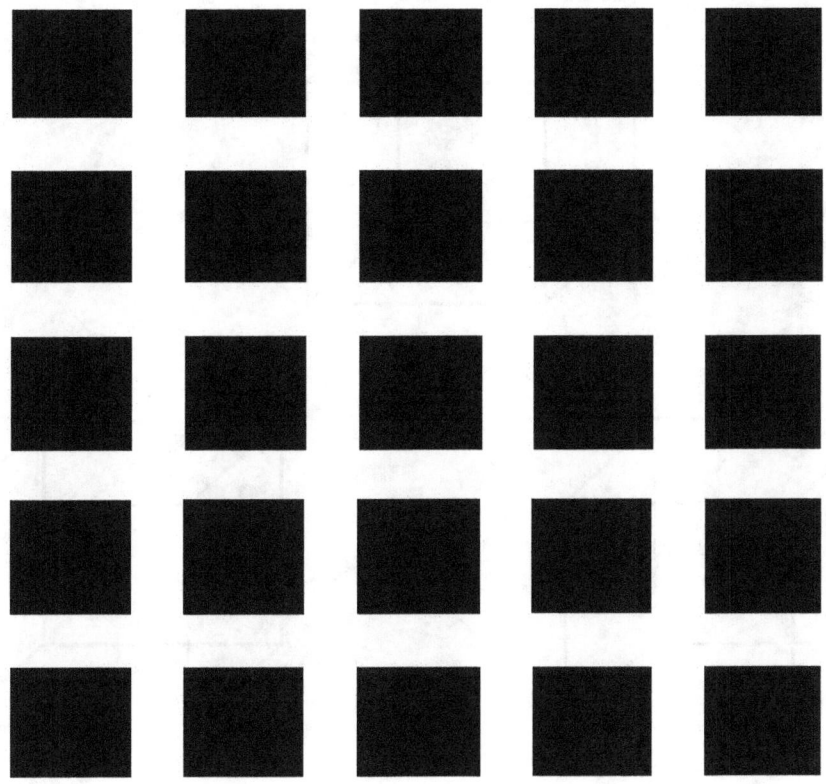

An example of the Hermann grid illusion. Dark blobs appear at the intersections.

Ambiguous Depth Illusion:

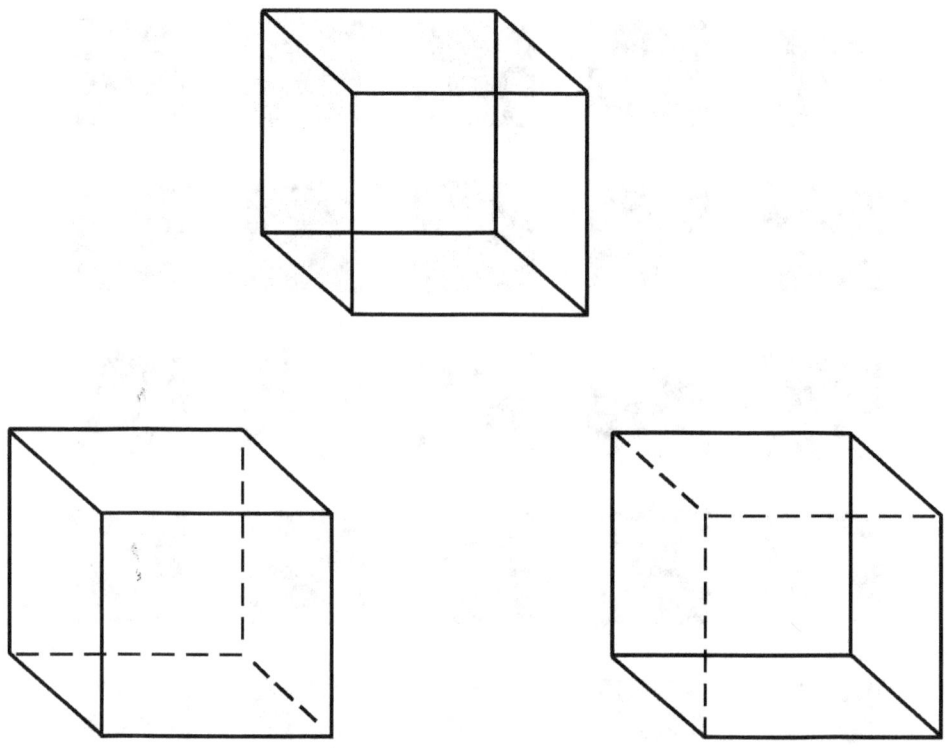

The Necker Cube is an optical illusion first published as a rhomboid in 1832 by Swiss crystallographer Louis Albert Necker. It is a wire-frame image of a cube in perspective. In this illusion, when two lines cross, the picture does not show which is in front and which is behind. This makes this image ambiguous. When you stare at this image, it will often seem to flip back and forth between the two valid interpretations.

The *"Hering Illusion"* is a geometrical-optical illusion and was discovered by the German physiologist Ewald Hering in 1861.

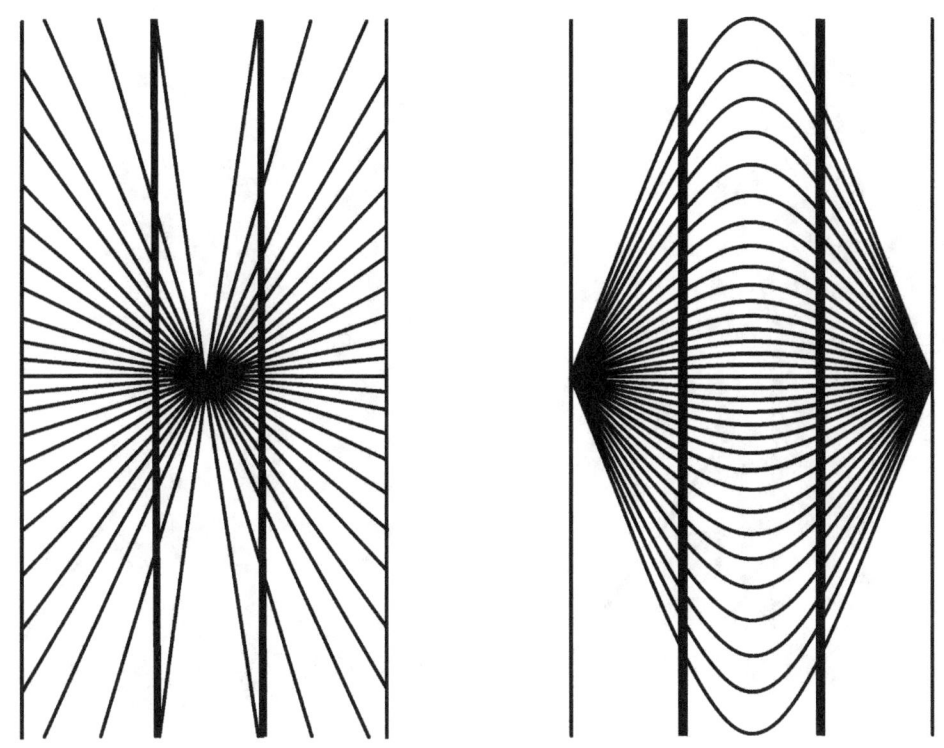

When looking at this illusion, we seem to see a pair of bowed or curved lines placed in front of a series of other lines. In reality, these bowed lines are parallel, and only appear to be curved.

The "*Poggendorff Illusion*" is an image where thin diagonal lines are positioned at an angle behind a wide stripe. Named for Johann Poggendorff (1796-1877). A German physicist who described it in 1860.

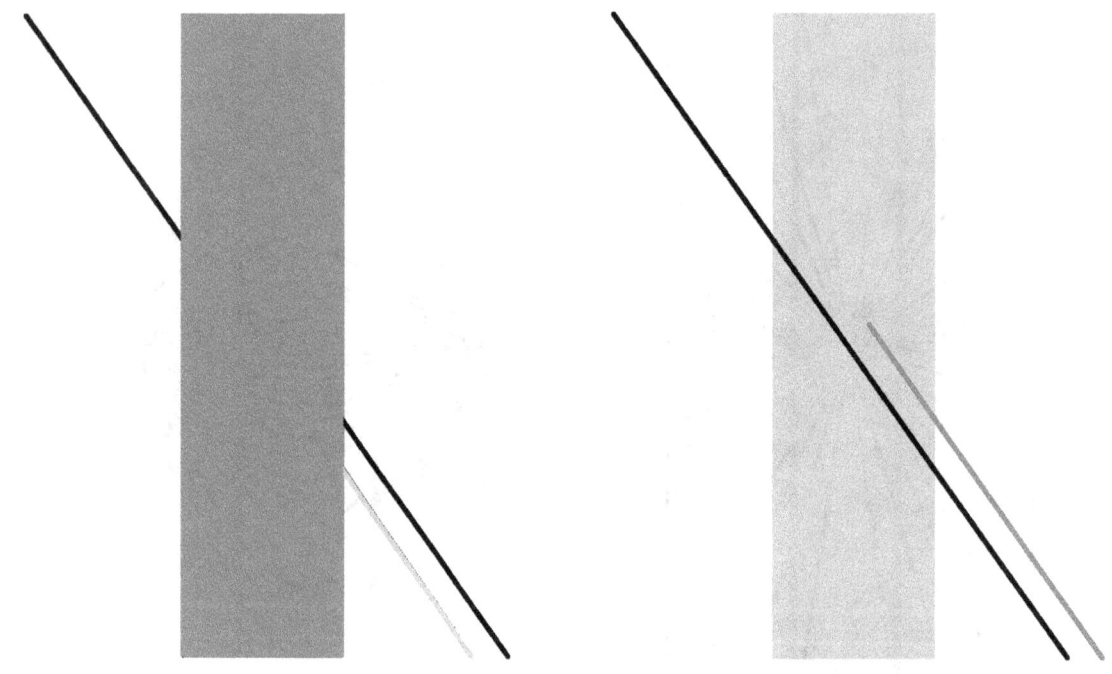

When you look at these thin lines, they appear to be misaligned. In the example on your left, the black line on the left appears to line up with the black line on the right. In actuality, the black line and the grey line match up.

A geometrical illusion of the "*Ponzo Illusion*", named after Italian psychologist Mario Ponzo, (1882-1960).

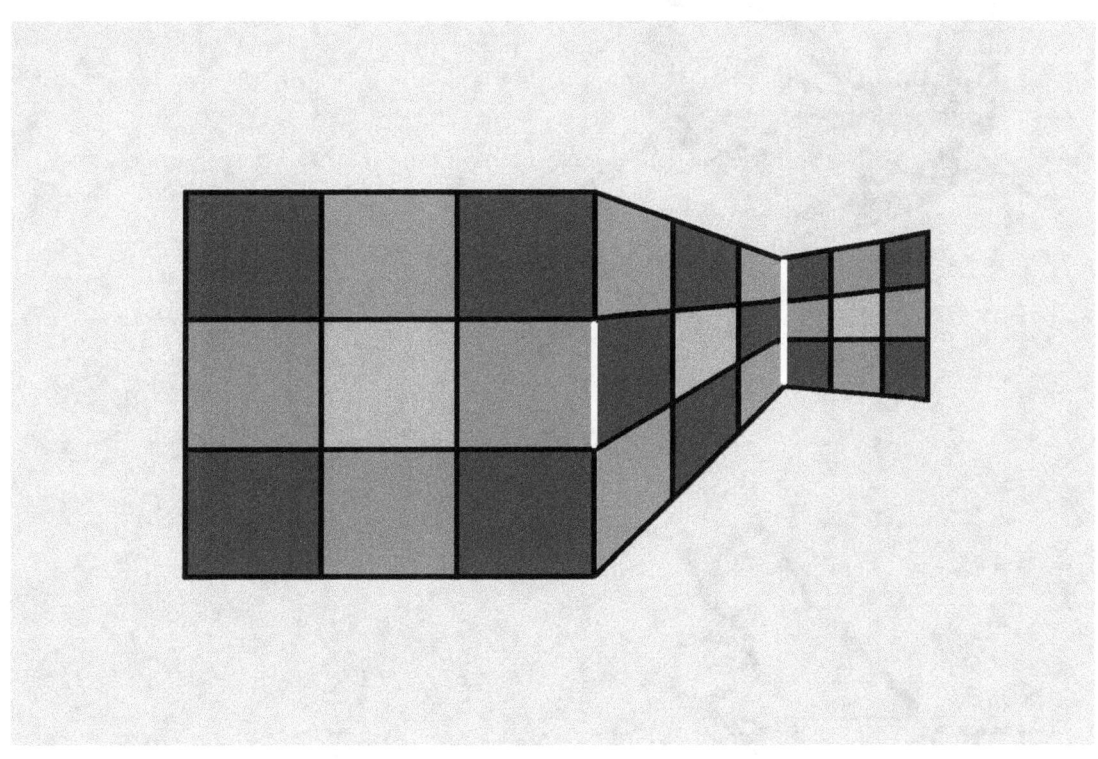

The white line closest to you appears to look smaller than the one furthest to you, but are exactly the same size.

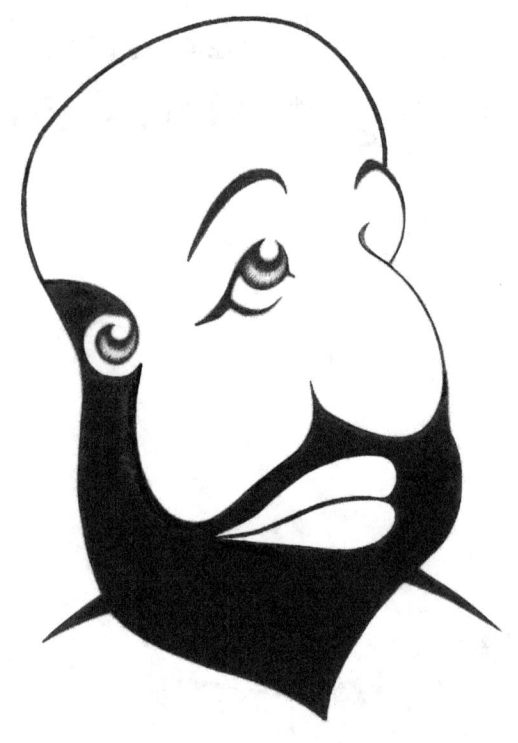

See the mad guy?

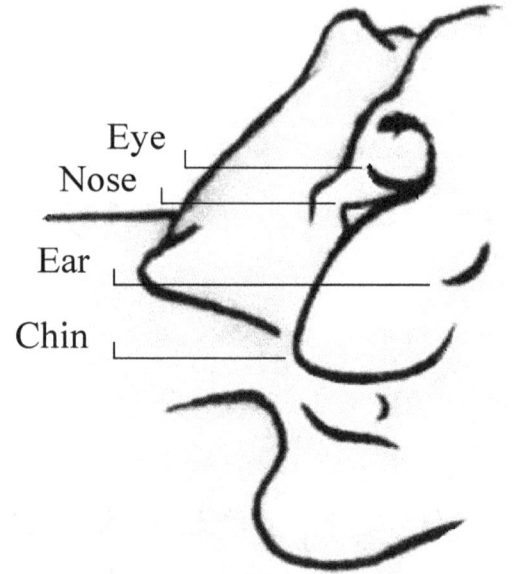

See the woman sleeping?

www.ingramcontent.com/pod-product-compliance
Lightning Source LLC
Chambersburg PA
CBHW080839170526
45158CB00009B/2591